Photography and Tibet

exposures

EXPOSURES is a series of books on photography designed to explore the rich history of the medium from thematic perspectives. Each title presents a striking collection of images and an engaging, accessible text that offers intriguing insights into a specific theme or subject.

Series editors: Mark Haworth-Booth and Peter Hamilton

Also published

Photography and Africa Erin Haney
Photography and Anthropology Christopher Pinney
Photography and Archaeology Frederick N. Bohrer
Photography and Australia Helen Ennis
Photography and China Claire Roberts
Photography and Cinema David Campany
Photography and Death Audrey Linkman
Photography and Egypt Maria Golia
Photography and Exploration James R. Ryan
Photography and Flight Denis Cosgrove and William L. Fox
Photography and Humour Louis Kaplan
Photography and Ireland Justin Carville
Photography and Italy Maria Antonella Pelizzari
Photography and Japan Karen Fraser
Photography and Literature François Brunet
Photography and Science Kelley Wilder
Photography and Spirit John Harvey
Photography and Tibet Clare Harris
Photography and Travel Graham Smith
Photography and the USA Mick Gidley

Photography and Tibet

Clare Harris

reaktion books

For Anthony Aris (1946–2015)

Published by Reaktion Books Ltd
Unit 32, Waterside
44–48 Wharf Road
London N1 7UX, UK
www.reaktionbooks.co.uk

First published 2016

Printed and bound in Hong Kong

A catalogue record for this book is available from the British Library

ISBN 978 1 78023 652 0

Contents

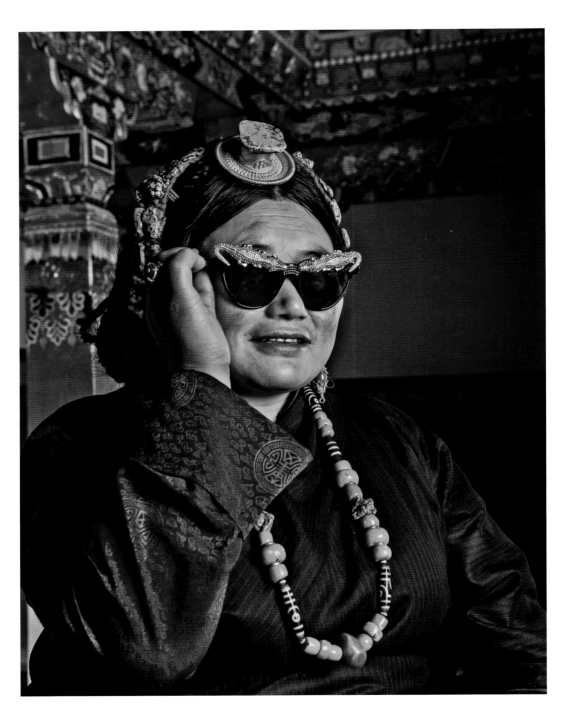

Note on Language

Since this book is designed for the general reader, I have kept the use of foreign language terms to a minimum. Where Tibetan words do appear, they have been rendered in a phonetic version, rather than the more taxing transliterated form. I have generally given the Tibetan terms for areas such as Kham and Amdo (rather than Sichuan and Qinghai, as they are now designated in the People's Republic of China) although the shape of contemporary borders does not directly match the historic Tibetan ones. When writing about India before 1947, I have retained the names of places like Calcutta (now Kolkata) and Bombay (now Mumbai) as they appeared in the original British sources I consulted.

Frontispiece
Nyema Droma, Tibetan woman in
Lhasa, 2014, digital C-print.

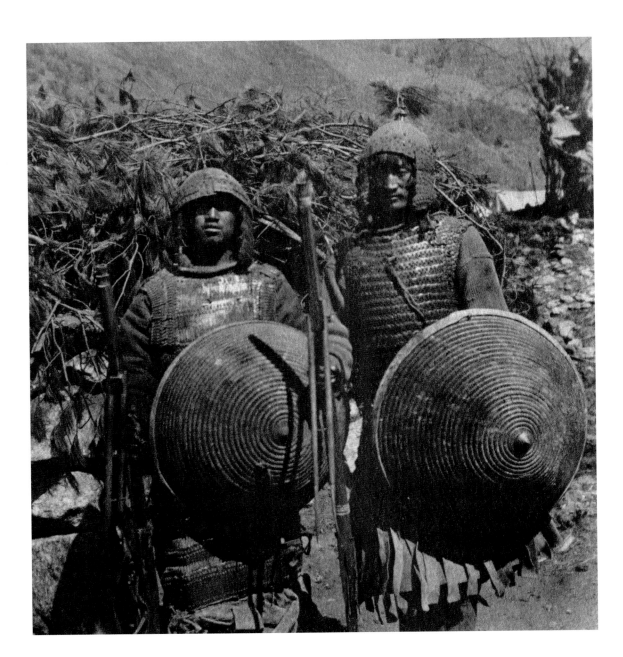

Prologue

In 1905 the soldier, medic and Tibet scholar Laurence Waddell published *Lhasa and its Mysteries*, his account of the British military 'Mission to Tibet' of 1903 to 1904. Within its pages, he included a photograph of two Tibetan warriors.[1] Having been present throughout the expedition led by Colonel Francis Younghusband, Waddell had witnessed the slaughter of many Tibetans as they attempted to resist the march of the imperial army towards their most sacred city, Lhasa. When it came to preparing his publication, he apparently needed an illustration to represent the warlike bearing of Tibetan men and to demonstrate that Younghusband had been opposed, if by an ill-equipped foe. Alongside the image, Waddell's text trumpeted the superiority of British fire power within a teleology of technological and civilizational progress, in which his colleagues deployed the Maxim machine gun, while the Tibetans relied on crude matchlocks and amulets blessed by monks. For the mission leader, Younghusband, such faith in Buddhism provided one of the justifications for his assault on Tibet and he had embarked upon it with the avowed intention to 'smash' the 'filthy, lecherous lamas' who he believed kept their followers in a state of abject poverty and devotion.[2] Much later in life, perhaps suffering from some guilt, he changed his mind and professed to an admiration for Tibetan Buddhism and the country that had nurtured it.

The debate about whether Tibet would be construed by outsiders as a feudalistic backwater where religion had caused cultural stagnation for centuries, or a paradise populated by enlightened beings, will feature throughout this book, since photography has regularly participated in the promotion of such imaginings. Waddell's picture of two Tibetan soldiers

1 Two 'Tibetan' soldiers, from G. J. Davys's 'Mission to Tibet' album, created after 1904, silver print.

also alerts us to another theme: of photographic veracity and its capacity to be conscripted into narratives both negative and benign. For Waddell's purposes, much of the effectiveness of that photograph derived from the implication that it had been taken in Tibet proper and portrayed vanquished Tibetan combatants. However, it was actually created in Chumbi, a Himalayan valley connecting Tibet and India, and the dejected-looking 'Tibetans' were in fact local porters in the employ of a small contingent of British troops that had been left behind while their comrades marched on towards Lhasa. Furthermore, their shields and guns had been borrowed from a Buddhist temple in the vicinity, where such obsolete equipment was traditionally displayed to symbolize a battle against invisible demons. This may explain why the 'soldiers' are actually wearing their armour back to front. The pertinence of such micro-historical details only becomes fully apparent when we turn to an unpublished source: a substantial photograph album assembled by an officer of the Tibet Mission on his return to England and that is now stored at the Royal Geographical Society in London. It contains a print of the same subject, but this time its compiler, Lieutenant G. J. Davys, has captioned the picture: 'two faked Tibetan soldiers'. Those few words reveal that the image had been consciously staged in Chumbi, very probably with the intention of providing Waddell with the visual evidence he needed to convince British readers of the validity of Younghusband's actions in Tibet.

In what follows, we will encounter numerous other instances where the archive records a rather different history from that presented in the visual fictions of popular print culture. In the case of Tibet, the tension between the camera's twin capacities to 'objectivize and subjectivize reality' has been acutely felt and continues unabated to the present day.[3] This has been evident since the mid-nineteenth century, when the inaccessibility of the country drove British civil servants to attempt to penetrate its borders and photograph it for governmental documentation projects. When that failed, they resorted to reconstructing Tibet elsewhere. In the twentieth century, Tibet's apparent resistance to photography was overturned by an intrepid few from several different nations, but I argue that it was precisely because non-Tibetans generally lacked ready access to or substantial first-hand knowledge of the country that myths of the Imperialist, Shangri-Laist or Maoist varieties became so potent and so widespread. The first two chapters of this book

therefore explore how photography was enlisted to fill the cartographic and epistemological void engendered by fantasies of a place called Tibet.

One of the challenges of writing a short introductory survey of photography and Tibet lies in the fact that both terms are notoriously slippery. Not only is photography a highly mutable medium that defies easy definition, but so is the concept of Tibet. As a geographical or political entity its boundaries have always been opaque and there is currently no nation called Tibet, since the historic heartlands of Tibetan culture have been subsumed within the People's Republic of China (PRC). Whether Tibet was ever an independent country prior to the Maoist annexation policies of the 1950s is still much disputed among politicians, historians and especially Tibetans.[4] Some claim that it came closest to nationhood during the rule of the 13th Dalai Lama between 1879 and 1933. Others argue that the longstanding priest–patron relationship between the leaders of Tibetan Buddhism and the emperors of China meant that Tibet had always been a vassal state. However, there is no doubt that between the seventh and ninth centuries the Tibetans possessed a substantial empire that extended into parts of Central, East and South Asia and that in later centuries principalities under the control of royal households were established across the Tibetan plateau and the Himalayas. This book therefore includes references to areas that originally fell within the orbit of Tibetan aristocratic families and/or Tibetan Buddhist institutions but which are now within the nation-states of India (such as Spiti, Ladakh, Sikkim and Darjeeling), Nepal and Bhutan. Given this wide geographic spread over political borders both ancient and modern, Tibetans and academics have often delineated 'Tibet' according to linguistic, ethnic and religious criteria. My working definition for this publication therefore encompasses the several million Tibetan-speakers in the People's Republic, the tens of thousands of followers of Tibetan Buddhism living in South Asia, and the many members of the Tibetan diaspora, who currently reside everywhere from San Francisco to Sydney.

For reasons that will become only too apparent in the following pages, the history of the relationship between photography and Tibet is somewhat difficult to reconstruct. This is partly due to the misidentification of prints and negatives associated with Tibet in museums and private collections around the world and the politically driven manipulation of the term 'Tibet'

in the narratives in which photographs have been inserted. It is also because of the general neglect of the subject by scholars, which means that there is very little analytical literature to consult. More pointedly, the destruction and inaccessibility of important bodies of material (particularly of photographs produced by Tibetans themselves) means that some topics simply cannot be easily researched. Although I have unearthed and analysed much previously unpublished material here, it has regrettably proved impossible to give as much attention to Tibetan photographers as to the foreigners who pictured their territories, their culture and their religion. However, in the final chapter of this book I examine how the products of the camera have been adopted by Tibetans and integrated into a religio-cultural system that enables a photograph to have agency, both as a sacred object and a potent device in the assertion of Tibetan identity. This process could be said to have begun in earnest when portraits of the 14th Dalai Lama were inserted into amulets as protection against the advance of the People's Liberation Army in the 1950s. In an ironic twist of the tale of 1903–4, when Tibetans faced another colonizing army they used a technology introduced by the British in their attempts to repel the Chinese. This study considers many other instances in which photographs have played a role in defending, inscribing and imagining a place called Tibet. In all of them, whether created by Tibetans, their admirers or their detractors, Tibet remains a contested space and subject.

2 Hand-tinted print of the 14th Dalai Lama inserted into a Tibetan Buddhist amulet for protection, Tibet, 1950s.

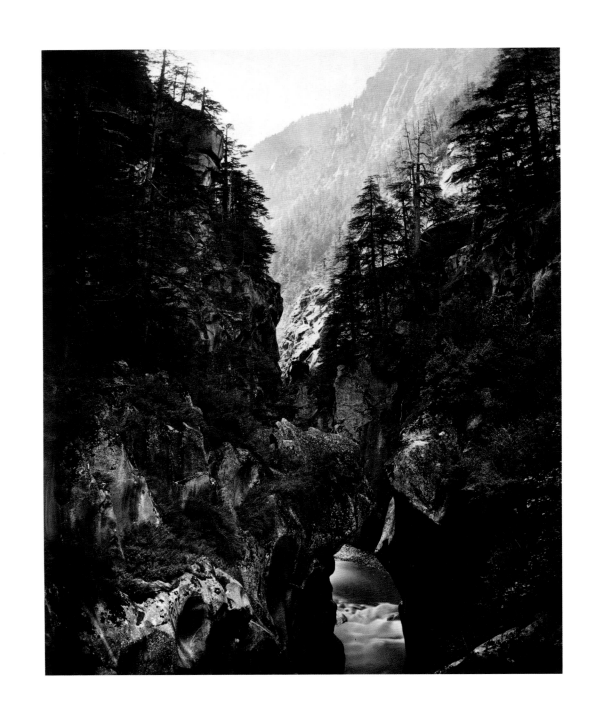

Picturing Tibet from the Periphery

In the second half of the nineteenth century, when the practice of photography was already well established across much of the world and its instruments had been deployed to document several other regions of Asia, Tibet remained uncharted territory. It was a closed land, jealously protected by its government and people from the encroachments of foreign visitors. Knowledge of the country among outsiders was limited and the accounts of the few travellers who had managed to visit in previous centuries were filled with tales of the strange religious practices of its occupants and the dramatic features of its environment.[1] Their publications, however, were rarely accompanied by illustrations. The drive to be the first to picture Tibet photographically was therefore inspired by two principal concerns: that it was an empty space on the world map which had yet to be scientifically recorded and that it contained a populace that was said to indulge in esoteric rituals that had never been photographed before.

From the outset, Tibet presented a troublesome but tantalizing prospect for photographers from outside its borders. For the leaders of the neighbouring nations of Russia, China and British India in particular, its inaccessibility posed both a challenge and an opportunity in military, political and strategic terms, for which the services of their intelligence agents, cartographers, soldiers and photographers – roles that were often combined in this period – would be required. By the close of the nineteenth century, Tibet still represented, as the viceroy of India, George Curzon, put it, the 'one mystery' that had been 'left to the twentieth to explore'.[2] Lord Curzon was therefore much gratified when, in 1904, a British army expedition reached the Tibetan capital and could finally proclaim that there were 'no more forbidden cities which men have not mapped and photographed'.[3]

3 Samuel Bourne, 'Rocky channel of the Ganges at Bhairamghati, No. 1538', 1869, albumen print.

15

This account begins, however, by focusing on nineteenth-century attempts to fill an empty space in the colonial cartographic imagination with the evidence that photography was thought to supply. In the Victorian period, such faith in photographic veracity led to concerted efforts to enter Tibet from its peripheries in which agents of the British Empire were willing to take serious risks. When they failed (as they often did) the camera was directed at the Tibetan Buddhist communities of British India instead, or used to create fabrications of the fabled land in the more accessible and culturally cognate regions of the Himalayas. For many decades this massive mountainous area was the closest that explorers, soldiers, spies, missionaries, climbers and even holidaymakers could get to Tibet itself. Since so many of the images they generated have since been archived, labelled or published as if they had been produced in Tibet proper, this chapter considers the history of their creation and seeks to overturn such misidentification. By focusing on British India, the location where the majority of this activity was enacted, it places the rise of photography *of* – rather than *in* – Tibet in the context of geopolitics and the demands of popular print culture. For the British government, its operatives and the viewing public, it seems there was much to be gained from picturing the land that lay beyond the fraying edge of empire.

The Search for 'Tibetan' Landscapes

On 19 August 1863 a middle-aged English soldier called Philip Egerton produced what is probably the first photograph ever taken in Tibet.[4] It was created in the westernmost reaches of the country after Egerton had crossed the border with British India and managed to proceed for a few miles into Tibetan territory. But this was to be a fleeting photographic encounter, since as soon as the Tibetan authorities discovered that a foreigner was in their midst, he was swiftly ejected. Despite this ignominious departure, Egerton could still trumpet his success in fulfilling the wishes of his superiors, who had urged him to use a camera to research a place beyond their control and purview.

Egerton had travelled to India in 1842 on the completion of his military training in England and, once based in the subcontinent, had risen rapidly up the ranks of the colonial administration. By 1862 he had been appointed

4 Philip Egerton, 'Bridge of rock', 1863, western Tibet, albumen print.

Deputy Commissioner for Kangra, a district in the foothills of the Western Himalayas that was overseen by the British from the small hill station and army cantonment of McLeod Ganj near Dharamshala (now in Himachal Pradesh). Not long after his arrival there, it became the place where the remains of one of the titans of imperialism, James Bruce, the 8th Earl of Elgin, were interred. It is perhaps surprising that – after serving as the High Commissioner for China during the 'Opium Wars' and the 'Sack' of Beijing in 1860, and then briefly as the viceroy of India – such a grand (but problematic) figure would end his days in a Himalayan hamlet, but in 1863 Elgin's body was buried in the cemetery of St John in the Wilderness, an archetypal English-style church nestled in the forest on the approach to McLeod Ganj. According to Egerton, the earl's heart had failed when he attempted to cross one of the highest passes in the western Himalayas in pursuit of a passage to Tibet and its riches.[5] It is therefore no small irony that the grave of a British imperialist who had set his sights on Tibet is now passed on a daily basis by busloads of tourists, pilgrims and Tibetans on their way to McLeod Ganj to encounter its most famous living inhabitant: the exiled leader of Tibet, the 14th Dalai Lama.

It was from that Himalayan outpost of Empire that Philip Egerton had departed in 1862 on a journey that culminated in his brief glimpse of Tibet. As he later wrote in his *Journal of a Tour through Spiti to the Frontier of Chinese Thibet*, Egerton had been tasked to continue the Earl of Elgin's search for a route that would provide the British with access to the 'Chinese Empire' and the possibility of fostering trade relations with 'that jealous nation' via the services of the Tibetan government.[6] His official mission was designed to document the topography that lay between the Himalayan foothills and Tibet in order to establish whether English 'manufactures' could be brought into the heart of Central Asia and thereby extend 'civilisation to the barbarous hordes which people those vast tracts', as Egerton put it.[7] Of course, if a path between Tibet and India could be forged, there would be other benefits for the British in terms of extracting the valuable raw materials, ranging from salt to gold, that were believed to exist on the Tibetan plateau. In particular Egerton was instructed to assess the existing arrangements for the movement of the fine wool called *pashm* (pashmina) that was gathered from goats on the Tibetan plateau, woven into fine shawls in India and then marketed internationally as a luxury product of 'Cashmere'. Having ascertained that

this activity was already extensive and potentially highly lucrative, his report concluded with the hope that 'even the looms of Manchester and Glasgow' might one day profit from it.[8] At this juncture Egerton and his colleagues envisaged Tibet as a putative extension of the British Empire and a terrain ripe for exploitation, so long as certain obstacles could first be overcome. But those obstacles were substantial: the Tibetans were firmly opposed to allowing strangers into their country and that country was, in a very real sense, obdurately resistant to exploration and colonization. A vast barrier of rock called the Himalayas lay between Tibet and the expansionist ambitions of the British in India and yet it was precisely that barrier which was to prove so alluring for British photographers and those who viewed their work.

The photograph Egerton took on the extreme edge of western Tibet neatly summarizes these points, since it is the product of an incident when he was both expelled by the Tibetans and repelled by their intractable environment (illus. 4). At first sight it is an undramatic picture, but the story behind its creation is rather the opposite. The image partially records a rock bridge that had been formed when a 24-metre (80-ft) block of limestone crashed down the mountainside at some point in prehistory. Egerton reports that he could not fit this immense object into one photographic frame and that in attempting to do so, by jumping from one rocky platform to another, he damaged his legs so badly that he could not walk for the remainder of the trip.[9] He had risked life, or more specifically limbs, to capture just two fragmentary views of the bridge, not to mention the fact that it had taken two months of marching through treacherous passes, deep ravines and boulder-strewn glaciers in the high-altitude region of Spiti to arrive there. Seventy 'coolies' (porters) had been enlisted from the local area to transport Egerton and his equipment to its higher reaches and a female member of the team had died when attempting to cross the freezing Spiti River. However, in his account of the journey, Egerton still manages to cast himself as a hero, both for saving the woman's companion from a similar fate in the icy torrent, and for doggedly persisting with his mission, irrespective of the danger to himself and others. He wrote, in decidedly imperialist fashion, that he deemed the endeavour to have been entirely worthwhile since it had allowed him to acquire photographs of 'people and places probably never before delineated with accuracy'.[10]

Actually, Egerton's travels in the remote Himalayan regions neighbouring Tibet had been preceded two years earlier by another military man, Captain Robert Melville Clarke. During a tour that departed from Shimla, the main administrative centre of the British government in the Himalayan foothills, to head for Ladakh, Melville Clarke had crossed the 17,000-foot (5,180-m) Bara-lacha pass. On finding his eyes 'at once possessed by the desolate grandeur of the scene', had photographed it.[11] Between them, Melville Clarke and Egerton were unwitting pioneers in what was to become the major preoccupation of other British photographers in the late nineteenth century who would dedicate themselves to capturing views of the Himalayan environment devoid of its inhabitants. But in the era prior to the establishment of landscape photography as a distinct genre, Egerton was exceptional in that he also documented some of the individuals he met on his travels. For example, when accompanied by a Moravian missionary who spoke the Tibetan language, Egerton managed to persuade the abbot and monks of a monastery in Spiti to be photographed, though he admits that the task had been made easier by the fact that 'All their reverences had drunk as much *chang* [barley beer] as was good for them' (illus. 7).[12] It also proved relatively

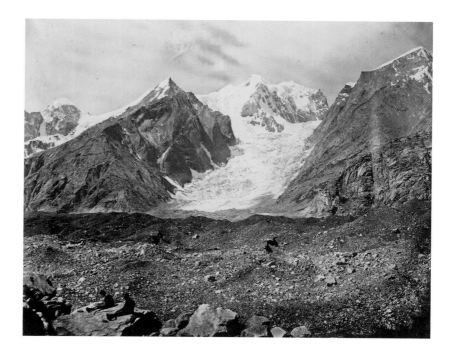

straightforward to photograph the *nono*, or headman, of the area, since Egerton was an agent of the British Empire who, alongside his other duties, had been sent to ascertain whether its residents paid taxes. Unsurprisingly, the *nono* was keen to avoid such a burden, so he agreed to enforce the British Indian Government's civil and penal codes within his territory and to sit for the Englishman's camera (illus. 8). Remarking on the resulting portrait, Egerton opined that 'Anything more inane and helpless than the old gentleman's face is impossible to conceive,' and he promptly sent a copy to his superiors to indicate the character of their latest 'native' recruit.[13] In documenting an apparently compliant subject who could assist the British in facilitating relations with Tibet, Egerton established a precedent that would be repeated by future generations of colonial officers. His actions also attest to the close interplay between photography, colonial documentation and political power that would recur in Anglo-Tibetan relations well into the twentieth century and which would frequently give rise to tension. In fact, the headman of Spiti had endeavoured to explain to Egerton why his fellow

21

Tibetan speakers and followers of Buddhism across the border in Tibet were so averse to his entry into their country. The *nono* recounted a Tibetan legend in which it was prophesied that they would one day be 'dreadfully oppressed' by a race of *piling* or outsiders.[14] Although he had been reluctant to be photographed, the *nono*'s remarks suggest that it was not so much superstition that made Tibetan Buddhists fearful of the camera (as was commonly assumed by colonialists when they attempted to photograph 'native' people in the nineteenth century), as anxiety about the potentially violent intentions of those who wielded it. This was to prove to be a premonition of things to come.

At around the same time that Egerton was in Spiti, two other British soldiers were touring in the uppermost reaches of the Indus River in the neighbouring region of Ladakh. It, too, was a predominantly Tibetan Buddhist area with many monasteries, of which the most substantial and wealthy was the main seat of the Drukpa (or 'Red Hat' lineage of Tibetan Buddhism) at Hemis. Founded in the seventeenth century, Hemis monastery was evidently renowned in the nineteenth for its *cham* (monastic masked dance), since it inspired those two members of the British Indian government's Topographical Survey unit to deviate from their usual activities, such as measuring distances and marking locations on maps, to record it in text and photographs. The photographer, Captain Alexander Melville, had been surveying in Ladakh between 1857 and 1864. His colleague, Captain Henry

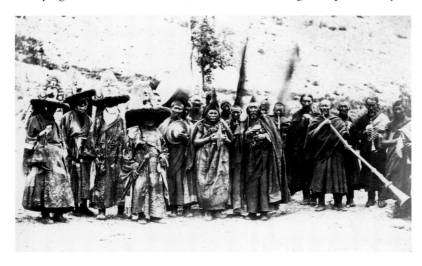

7 Philip Egerton, abbot and 'Monks in procession', Spiti, 1863, albumen print.

22

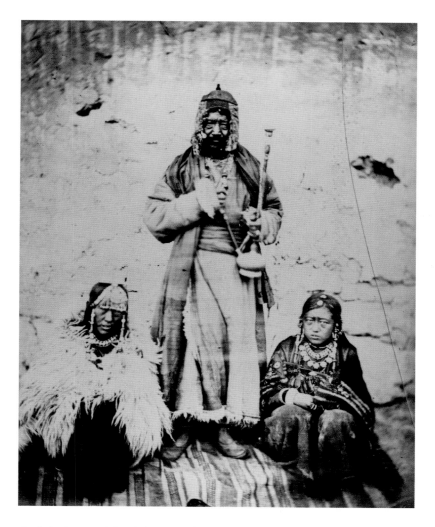

Godwin-Austen, joined the same department in 1856 but had only been stationed in Ladakh since 1862. Two years later Godwin-Austen published 'Description of a Mystic Play, as performed in Ladak, Zascar, &c.' in the *Journal of the Asiatic Society of Bengal*. This account of the monastic building, the monks' attire and their performance at Hemis was clearly based on his own observations supplemented by Tibetological information derived from the work of the Moravian missionary Heinrich August Jäschke.[15] Despite

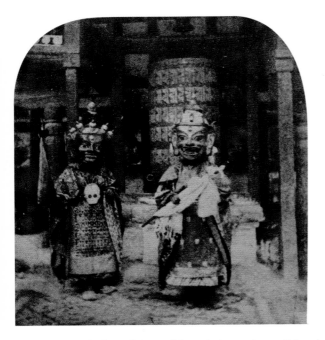 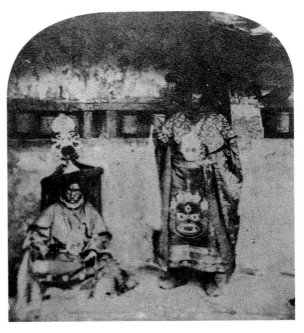

being the beneficiary of the missionary's erudition, however, Godwin-Austen was still left lamenting:

> What this strange masque was intended to represent is more than I can say, and the priests of the monastery seemed to know as little of the matter, or perhaps could not explain it, mixed as the subject must be with theological Buddhist mysteries, the ridiculous grafted upon it for the amusement of the populace.[16]

Perhaps it was precisely because the 'strange masque' seemed so incomprehensible that Godwin-Austen's text was augmented by ten illustrations by Melville, which pictured the monks and the various costumes they wore for a *cham* in celebration of the life of a major figure in Tibetan Buddhism: Padmasambhava.[17] Also, since the prints were half-stereos (that is, one of two images created by a stereoscopic camera) they raise the intriguing possibility that the monks' dances had stimulated another kind of performance back in the plains of India and at the heart of the colonial administration. Since

9, 10 Alexander Melville, monks at Hemis monastery in their *cham* costumes, 1864, half-stereo albumen prints.

24

Godwin-Austen's paper was read before an audience of scholars and leading figures in the civil service at the Asiatic Society in Calcutta (now Kolkata), it may well have been illustrated with stereoscopic images.

The stereoscope had been invented in the late 1830s and its capacity to render a sense of depth had been avidly embraced by surveyors and topographers seeking scientific accuracy. It had also rapidly become a popular device for entertainment in the parlours of middle-class homes across Europe and America, where users took special pleasure in inspecting images of distant peoples and places.[18] When viewed in a purpose-made handheld device, the immersive effects of this novel three-dimensional photographic technology imparted a vivid sense of 'being there' for armchair explorers who could not make the arduous journey to remote environments such as the Himalayas. Thus in 1864 Melville's photographs from Ladakh reproduced some of the most inscrutable but alluring aspects of Tibetan Buddhist culture for the first time and very probably animated them in hyper-realist mode for the mandarins of Calcutta. The mystique of Tibetan monks in the elaborate regalia of masked dance would become a leitmotif for future photographers and, by the end of the nineteenth century, one of the most popular collectibles within the print culture of colonial India.

However, prior to the preoccupation with Tibetans as a people and their religion as a practice, another major genre emerged that was indirectly inspired by the idea of Tibet, if not its actuality: Himalayan landscape photography. On only his second ascent into the 'interior' beyond Shimla in 1863, the British photographer Samuel Bourne had planned to venture into Tibetan territory. He got as close as 80 kilometres (50 mi.) from the border but, rather than being repelled by Tibetans as Egerton had been, it was the 'uninteresting scenery' of bare peaks and valleys on the approach to Tibet that forced Bourne to turn back and focus on the verdant lower levels of the Himalayas instead.[19] Thereafter he made a career of photographing everything but Tibet, or rather everything that approached and approximated it. Importantly, unlike his predecessors who had travelled up the Himalayas with cameras, Bourne's mission was not military, topographical or governmental. It was motivated by the quest for the picturesque view, for acclaim in the burgeoning circles of amateur and professional photographers in the subcontinent and in Britain, and by a commercial imperative. Bourne was already a keen photographer when he

left England in 1863, and he arrived in Shimla with the intention of establishing a photographic studio there. From 1866 onwards the firm he created with Charles Shepherd soon became one of the most important in India, and the company, Bourne and Shepherd, continued to flourish well into the twentieth century. It was in large part due to Bourne's success as a landscape photographer in the Himalayas that the company gained its renown, but even before he made his first foray into those mountains, the young Englishman had begun to develop his skills and ideas in his home country. Writing for the *Nottingham Photographic Society Journal* in 1860, Bourne stated:

> If he is a true lover of nature (which every photographer should be), he knows that . . . sublime enthusiasm which a magnificent landscape never fails to kindle . . . and can transfer to his delicate and mysterious tablets, with absolute truth and unerring pencil, every feature of the grand spectacle spread before him.[20]

This quote encapsulates Bourne's nascent photographic philosophy; although 'mysterious', the camera's main advantages lay in providing an unerringly faithful record of nature. However, he was also firmly of the view that the photographer should be a person of 'taste and artistic perception'.[21] Without due consideration of composition, perspective, the distribution of light and shade and so on, he argued that photographs were mere 'accidents' arising from the exercise of mechanical skill. Over the course of his career, it would be this powerful alliance of mastery of technique and an unwavering eye for a good picture that would forge Bourne's fame and fortune in India and beyond.

Although he photographed many of the major monuments of the subcontinent, ranging from the Taj Mahal to the Hindu temples of Varanasi, it was Bourne's engagement with the natural beauties of the Himalayas, rather than the imposing edifices of the plains, that made him famous. In addition to generating hundreds of prints, Bourne wrote four long essays narrating his experiences in the Himalayas that were published in the *British Journal of Photography* between 1863 and 1870. Those articles make it possible for readers (both then and now) to follow the development of his work as it proceeded. In their pages he records the hazards of the journey, the difficulties of handling

photographic materials at high altitude, the pleasures of a clear day versus the troublesome presence of clouds on others, and his annoyance when dealing with porters whom, by his own admission, he beat with a stout stick when they threatened to abandon him. The existence of such rare accounts of the modus operandi of a nineteenth-century photographer, along with the indisputable quality of his pictures, have meant that Bourne is one of the most frequently discussed figures in the history of photography.[22] The majority of commentators portray him as one of the greatest exponents of the photographic picturesque in the Victorian era and a man who succeeded in transposing a European – and even a specifically British – aesthetic onto the crevasses and contours of the Himalayas.

For Bourne, the essential components of the picturesque in the English context were lush vegetation, distant hills or preferably mountains, an abandoned building or two, and water in some form. Such things were common in the north of Britain, but when Bourne arrived in India with these desiderata in mind he initially found its scenery wanting. On reaching Shimla, the summer capital of the British administration in 1863, he complained that there were 'no lakes, no rivers, and scarcely anything like a stream in this locality and neither is there a single object of architectural interest, no rustic bridges and no ivy-clad ruins'.[23] At first only 'the beautiful play of light and shadow' in the forests around Shimla stimulated his photographic interest, and the mountains beyond seemed decidedly unappealing. However, a close reading of Bourne's publications suggests that he gradually adjusted his tastes and altered his photography in response to changes in the terrain as he ascended towards Tibet. For example, on only his second Himalayan tour, in 1863, Bourne traversed a 15,000-foot (4,572-m) pass and was inspired to write: 'It has seldom, if ever, been my lot to look upon and photograph scenery so magnificent and beautiful as that I now met in the Wangu [sic] Valley.'[24] The trees, mountains and 'tumbling, foaming' river in this valley enabled Bourne to create images very much in line with the established criteria of the picturesque. However, when referring to higher elevations, Bourne's textual and visual vocabularies enter a notably different register. Commenting increasingly positively on the 'grandeur' of the 'imposing' mountain ranges, as well as on their 'wildness' and 'barrenness', Bourne appears to have become captivated. For example, the view from the

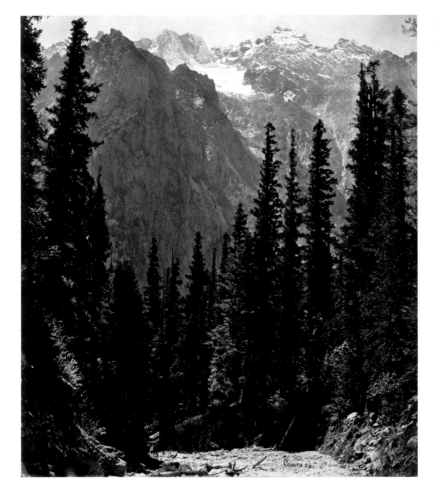

Meribel Pass that encompassed the Pir Panjal range and the vale of Kashmir elicits this response:

> What a scene was the whole to look upon! And what a puny thing
> I felt standing on that crest of snow! . . . To gaze upon a scene like
> this till a feeling of awe and insignificance steals over you and then
> reflect that in the midst of this vast assemblage of sublime creations,
> you are not uncared for nor forgotten.[25]

This paean of praise for the mountains concludes with thanks to the 'Almighty' who had 'upreared' them. Here and at several other points in his writing it becomes apparent that the higher Bourne travels, the greater his sense of proximity to God and the closer he comes to a rather different mode of aesthetic response: that of the sublime, rather than the picturesque. In the high peaks of the Himalayas, Samuel Bourne experienced precisely those sentiments that the eighteenth-century philosopher Edmund Burke had identified as the chief characteristics of the sublime: a heightened emotional state induced by awe-inspiring, even terrifying, sights and an awareness of the subordinate status of humans in relation to the overwhelming scale and majesty of nature.[26]

In fact, Bourne's essays suggest that he saw himself fighting a protracted battle to encompass the mighty scale of the Himalayas within the limitations imposed not only by his photographic equipment, but by the parameters of the English picturesque. Ultimately this struggle proved profitable in all senses of the word but, as the visual anthropologist Christopher Pinney has observed, Bourne's ruthless pursuit of the transcendent has meant that he can be branded as a rather 'unattractive . . . photographic imperialist'.[27] This is most palpable in a print labelled 'The Manirung Pass, No. 1468', in which he deviates from his usual tendency to omit human figures from a composition by including a small group of people (illus. 12). Compositionally their presence only serves to accentuate the vast scale of the snowfield and the height of the peaks beyond, and to emphasize the manner in which such an environment can appear to dwarf those who dare to enter it. But these individuals are actually some of Bourne's Ladakhi porters trudging through the snow. Viewing them as subordinate to nature elides the fact that they are also Bourne's maltreated inferiors, both within the racial hierarchy of colonialism and in the production of his photography. They are the workers who have suffered his blows and insults and yet have persisted in carrying his cameras along perilous tracks to reach high-altitude locations. Without those men and women of the mountains, Bourne would never have been able to experience such sublime scenes or to represent them photographically from a godlike vantage point.

However, concerns of this sort apparently did not trouble Bourne's contemporaries, since his portrayal of the Himalayas gained him enormous acclaim in photographic quarters in the nineteenth century. Among the markers of esteem he received were several prizes from the Bengal

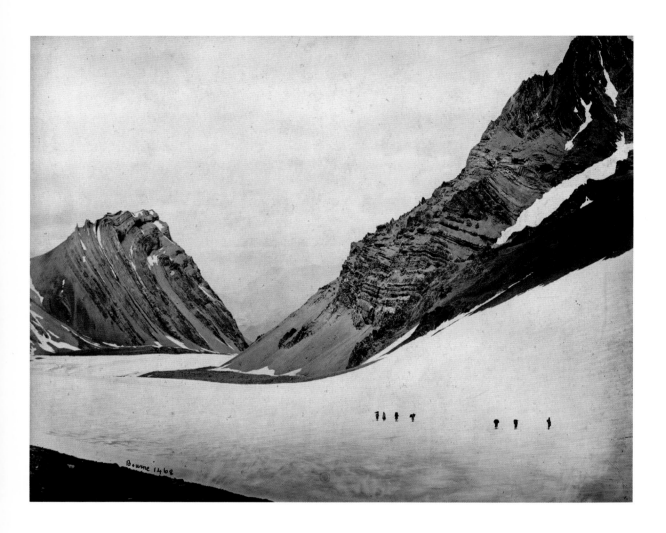

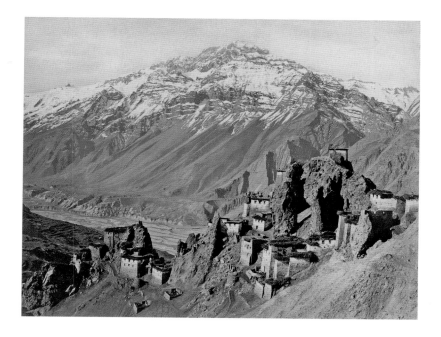

Photographic Society, a bronze medal at the International Exposition in Paris in 1867 and a gold medal from the viceroy of India in 1869. Both he and his company enjoyed great success in selling landscape photography; a Bourne print of the Himalayas soon became a favoured object for display in public exhibitions and private homes, and was collected in photographic albums in India and elsewhere. His endeavours helped to create a market for such images and inspired others, such as the anonymous photographer who produced a series of views of the Spiti and Kullu valleys for the Francis Frith Company in 1869.[28] Founded in the late 1850s, Frith & Co. were the largest producers of topographical prints in Britain and they regularly commissioned photographers living abroad to take pictures that could be assembled into albums or published within a larger series. Among the latter, Frith's *Photo-Pictures of India* contained hundreds of prints for their customers to choose from and by the 1870s a total of 48 pictures in their catalogue featured the Himalayas, indicating that the geographical region had become an essential element in any populist photographic survey of the subcontinent. A striking view of Dunkhar village and monastery in Spiti from the Frith series confirms

31

the appeal of the sublime landscape genre that Bourne had perfected and, in its framing of Tibetan Buddhist buildings against a backdrop of bare mountains, brings us back to the theme of this chapter. This image records a physical environment that, although technically within the borders of British India, is clearly unlike any other part of the country (illus. 13). It also portrays architectural forms of a distinctly different type from those of the plains, and it refers to a cultural and religious context that is neither Muslim nor Hindu, Sikh or Jain. Above all, the photograph demonstrates that the camera could be used to imagine a place that was otherwise inaccessible and unattainable. In short, it is an allusion to another land and a different group of people: Tibet and the Tibetan Buddhists.

Picturing 'Tibetans'

If the first photographs of 'Tibetan' landscapes were a by-product of the work of colonial officers whose main duty was to gather information visually, then so too were the portrayal of 'Tibetans' as a people. The inception of Tibetan portraiture as a genre follows a similar pattern to that of landscape, since it also began with the camera acting as an instrument of imperialist documentation before becoming the prized asset of commercial photographers catering to public demand for Himalayan exotica. Similarly, just as the earliest photographs of Tibetan environments were mainly created in British India rather than in Tibet proper, so were the first depictions of Tibetans. However, whereas landscape photography had begun as an adjunct to the Topographical Survey of India, it was the emergence of an anthropological survey movement that initiated the pursuit of pictures that could depict Tibetans collectively within colonial constructions of knowledge. Shortly after photography was established in India, it had been identified by the colonial authorities as eminently suitable for the documentation and taxonomization of those who had been colonized.[29] When allied with pernicious Victorian conceptions of race, it would be used to differentiate between the various 'types' of the subcontinent according to subcategories of ethnicity, religion, caste and occupation, and the results would be filed in British colonial archives in the visual equivalent of a census. The most extensive exercise

of this sort was the *People of India* project, directed by J. Forbes Watson and J. W. Kaye from their institutional base at the Indian Museum in Calcutta, with assistance from numerous members of the colonial services dispersed across the country.[30] The impetus for it arose from Charles Canning, the Governor General of India, and his wife Charlotte, who wished to have 'photographic illustrations . . . which might recall to their memory the peculiarities of Indian life' once they returned to Britain.[31] Beginning in the late 1850s, the project eventually came to fruition in eight volumes that were published between 1868 and 1875.[32] With coverage ranging from the southernmost tip of the subcontinent to the Himalayas in the north, Watson and Kaye succeeded in amassing a substantial photographic record of the diversity of peoples to be found within the territory of British India.[33]

Since Tibetans and other followers of Tibetan Buddhism were known to reside on the remote northern fringes of British India, their presence in this visual archive was deemed highly desirable – though difficult to obtain – from the outset. The services of colonial officers, soldiers and amateur anthropologists stationed in the Himalayas would therefore have to be enlisted. In fact, the endeavours of such individuals meant that the first volume of *The People of India* included sections on Tibet, Bhutan and Sikkim, and references to the rather opaque ethnic category of 'Bhotia', which was explained in the introduction:

> The inhabitants of the Himalayan valleys are of Tibetan origin,
> their language and associations differ from those of the people
> of the plains; to them, the name Bhotia, which belongs in strictness
> to the inhabitants of Tibet only, is generally applied; the Tibetans
> proper being on account of the extreme height, ruggedness and
> difficulty of the mountain passes . . . comparatively but little known
> to the inhabitants of Hindoostan.[34]

The reader's attention was then drawn to two pairs of photographs that were to be compared to identify physiognomic variation. Using the language and criteria of nineteenth-century physical anthropology, the difference between the Bhotias of the Himalayas and the Tibetans 'by birth and origin' was said to be visible in the 'markedly Tartarian' (Central Asian) features of the latter.

Although these distinctions are hardly supported by the illustrations, it is notable that photography is being instrumentalized here to make a connection between physical markers of ethnicity and a kind of environmental determinism. That is, in colonial scholarship of the 1860s, 'true' Tibetans were defined by dint of their inaccessibility on the Tibetan plateau, whereas the Bhotia of the Himalayan valleys were somehow less authentic as a result of their accessibility and visibility. Above all, both groups were a source of fascination due to their difference from the more frequently encountered and more readily photographed inhabitants of the plains of India.

In a climate preoccupied with racial classification and the photographic record, an individual who could produce images of the elusive mountain peoples of 'Hindoostan' could become a celebrated figure. Such an elevated status was achieved by Benjamin Simpson, a soldier and medic by profession whose work as an amateur photographer enabled him to participate in major displays of imperial documentation, such as the International Exhibition in London of 1862, where he showed eighty portraits of 'Racial Types of Northern India' and was awarded a gold medal for the quality of those pictures.[35] His high reputation also ensured that Simpson was one of the few names listed as a contributor of photographs to volume one of *The People of India*.[36] The military man's ability to create such useful and desirable photographs was clearly the result of being stationed in Bengal, the Indian state with the easiest access to the Tibetan Buddhist communities of Sikkim, Darjeeling and Kalimpong, all of which lay on long-established trade routes between India and Tibet.

It is therefore no surprise that in the pages of Edward Tuite Dalton's *Descriptive Ethnology of Bengal* (1872) we find Simpson's efforts in photographing the particularly difficult-to-reach peoples of the hills being most overtly commended.[37] Its preface states:

> It was of utmost importance that the wild tribes of India should be fully represented. Yet it is sometimes no easy matter to induce those strange shy creatures to visit even the stations nearest to them, and to induce them to proceed to a remote and unknown country for a purpose they could not be made to comprehend, would in many cases have been utterly impracticable.[38]

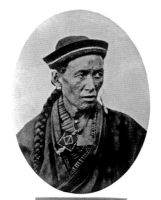

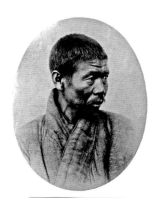

14 Benjamin Simpson, 'Bhotia. Buddhist. Tibet', from *The People of India*, vol. I (1868).

15 Benjamin Simpson, 'Tibetan. Buddhist. Tibet', from *The People of India*, vol. I (1868).

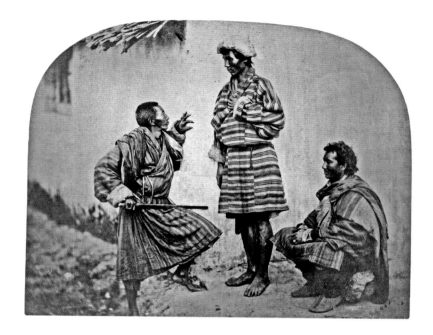

Among those incomprehensible purposes was the idea of photographing hill
people in the studios of Calcutta or even exhibiting them as 'live specimens'
in the museums of that city.[39] Since Simpson was often in the foothills of the
Himalayas in northeast India, such 'impracticable' procedures were actually
not necessary and it would soon be entirely possible to photograph 'shy'
Himalayan individuals in British hill stations, such as Darjeeling, for they
were places where the colonials and the followers of Tibetan Buddhism were
both very much at home.

Although it has rarely been acknowledged, from the 1870s onwards
Darjeeling was fast becoming one of the most significant locations in the
development of photography in British India. This was largely due to the
allure of its topography, but the ethnic diversity of the town was also a major
attraction for British photographers and their clients. Founded in the 1840s
as a sanatorium for recuperating soldiers, the station also had a cool climate
that made it a sanctuary for civilians seeking respite from the heat of the
plains, and by the close of the nineteenth century it had become one of the
top tourist destinations for European travellers in all of India. As its original

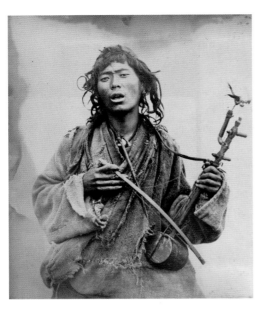

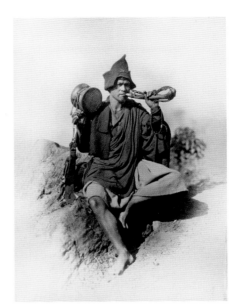

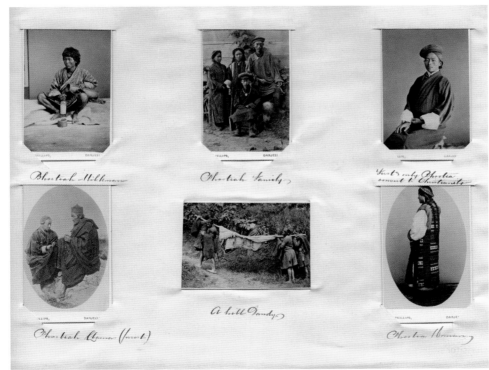

Bhooteah Milkmen

Bhooteah Family

First & only Bhootea convert to Christianity

Bhooteah Lamas (priest)

A hill Dandy

Bhootea Women

20 Thomas Paar, 'Mt. Everest – Greetings from Darjeeling', around 1900, embossed collotype postcard.

Mt. Everest Greetings from Darjeeling

17 Benjamin Simpson, Tibetan minstrel, 1870s, albumen print.

18 Benjamin Simpson, Tibetan Buddhist monk, 1870s, albumen print.

19 *Cartes de visite* produced by the Darjeeling photographer Robert Phillips and inserted into a page of a British visitor's photograph album, 1870s.

name, Dorje Ling, or the land of the thunderbolt in Tibetan, implies, it provided the opportunity to encounter the followers of Tibetan Buddhism at close quarters and to glimpse some of the highest peaks of the Himalayan range, including the massive mountain that had been officially named after George Everest, the Surveyor General of India, in 1865.

Exponents of landscape photography were therefore sorely needed in Darjeeling in order to provide visitors with a record of the exceptional physical features they had witnessed there. The proliferation of studios between 1870 and 1900 indicates that portrait photography was also equally highly sought after in the town. Such studios initially specialized in the manufacture of *cartes de visite*, the small-format cards with portrait prints attached to them that were particularly desired by those who had come 'up for the season' from Calcutta to enjoy the giddy round of social gatherings, or among members of the 'fishing fleet' who arrived in search of engagement opportunities. Johnston & Hoffmann, for example, generated numerous elegant portrayals of young English ladies that could be presented to their suitors (illus. 21). But Darjeeling was by no means a monoculture or a domain solely populated by the British, as the many surviving nineteenth-century prints from there attest to. The portraits of Tibetans, Lepchas, Bhutias, Nepalis and individuals from other parts of India that have been preserved in

public and private collections indicate that Darjeeling should really be construed as a highly diverse 'contact zone' where Europeans occupied the same space as long-established Himalayan communities, if in a condition of highly unequal power relations.[40]

It was members of those indigenous communities of northeast India that were of particular interest to amateur anthropologists in the colonial service such as Laurence Waddell. Alongside his official role as Assistant Sanitary Commissioner for the Darjeeling area, Waddell devoted his spare time to studying those who lived *Among the Himalayas*, as his memoir of twenty years there records.[41] His interactions with Tibetan Buddhists in particular eventually led to the publication of *The Buddhism of Tibet or Lamaism* in 1895, a book that made his name as an expert in all things Tibetan, but which was primarily based on observations and sources accumulated in British India.[42] It was during the long gestation of that book in Darjeeling that he also began to acquire photographs of Tibetans and to use them to illustrate his work. For example, a portrait of a young woman that features prominently in *The Buddhism of Tibet* as a generic illustration of Tibetan femininity implies that she had been photographed in Tibet. In fact, the woman, whose name was Lhamo, was born in Darjeeling but dressed, as Waddell records, 'à la mode' of Lhasa. This is revealed in an album created by Waddell in which Lhamo's portrait is just one of a set of images that had been produced in the Johnston & Hoffmann studio.[43] Now curated at the Royal Anthropological Institute in London, the pages of this album are filled with 'type' photography representing the many different communities of Darjeeling and its vicinity, including the 'aboriginal' Lepchas and Bhutias, as well as Tibetans who had migrated to Darjeeling on marriage or to pursue trading opportunities. Since Waddell was a communicating member of the Anthropological Institute in London and each subject was photographed in profile and full-face view, with notes on their age, marital status, religion and ethnicity included, it seems probable that Waddell commissioned this set of prints with specifically ethnological intentions in mind. On the other hand, when portraits of the same subjects were reproduced in publications destined for a non-specialist readership, such details were omitted, suggesting that for Waddell photography operated in two different registers according to the context of reception. Similarly, when the commercial photographic firm of Johnston & Hoffmann

21 Johnston & Hoffmann Photographers, unnamed British woman, Darjeeling, 1890s, cabinet card.

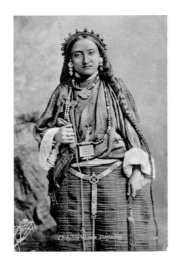

22 Johnston & Hoffmann Photographers, 'Thibetan Woman, Darjeeling', before 1895, collotype postcard. The same image was used in Waddell's book.

38

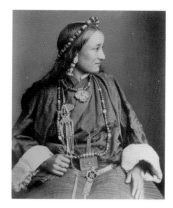

23 Johnston & Hoffmann Photographers, studio portrait of Lhamo, from the album of Laurence Waddell, around 1890, albumen print.

24 Johnston & Hoffmann Photographers, studio portrait of Lhamo's husband, Tashi Wangdu, from the album of Laurence Waddell, around 1890, albumen print.

sold portrayals of Tibetans in print and postcard formats, they too had little need for personal information. This process marked the birth of the Tibetan stereotype as a highly marketable product for sale to non-Tibetans.

In the burgeoning 'visual economy' of Darjeeling in the late nineteenth and early twentieth century, Johnston & Hoffmann were by no means alone in catering to the public enthusiasm for such imagery.[44] Since it was located in a prime position in the main square of the town near the hotels, restaurants, shops and clubs frequented by the British, the studio of Thomas Paar was ideally placed to dominate the market for studio portraiture and to purvey his wares.[45] With a wide range of painted backdrops and props to choose from, Paar's studio was the site of some of the most glamorous performances for the camera ever created in the Himalayas. Many of the studio's images feature Tibetans, Sikkimese, Nepalis, Indians and other local dignitaries, demonstrating that, although British-run, this was a social space that was not entirely closed to non-Europeans.[46] By examining prints from this studio along with information derived from textual and oral histories, we can begin to assign some agency to the individuals who frequented it but who were otherwise anonymized in popular publications and the commercial world of photography. A classic case in point is one of Paar's studies of a Tibetan woman (illus. 28). Standing before a painted rose arbor with grass at her feet and clothed in a full Tibetan-style outfit, she might at first appear to be out of place in an English garden setting, but the figure in this photograph is Ani Chokyi, the head of a prominent Tibetan-Sikkimese family, the owner of a number of businesses and one of the richest women in late nineteenth-century Darjeeling. She and her relatives were highly Anglophile, and she may therefore be construed as entirely at home in the photographer's simulation of Englishness. Ani Chokyi's husband, Ugyen Gyatso, was a celebrated participant in the exploration of Tibet on behalf of the British government, and in 1883 she had travelled with him to map the Yamdrok Tso, a previously undocumented lake in the south of the country. Her nephew, Sonam Wangfel Laden La, joined the imperial police force for the Darjeeling district in 1899 and became an important player in fostering diplomatic relations between British India and Tibet in the first decades of the twentieth century.[47] As a young man he too was photographed by Thomas Paar and acted as his assistant. Like other affluent local families, Ani Chokyi's had close

Bhutia Lady

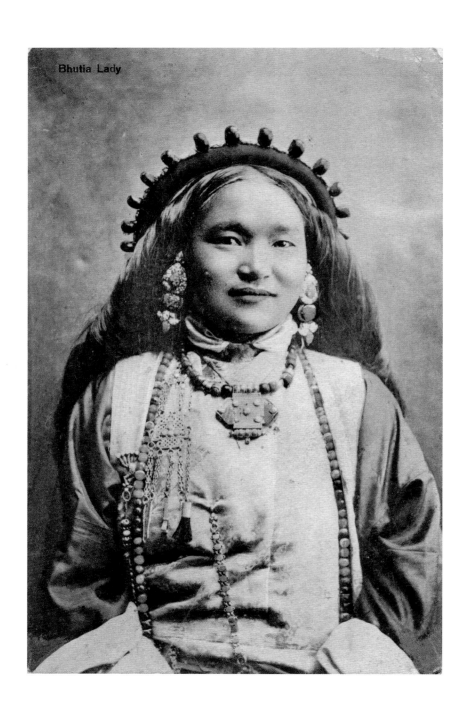

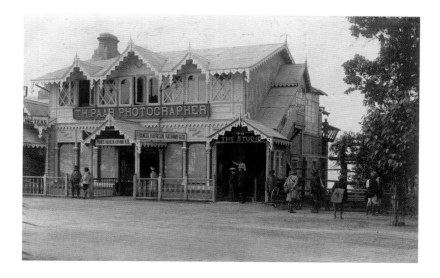

26 Thomas Paar, the photographer's studio in the centre of Darjeeling, 1906 or shortly thereafter, collotype postcard.

social ties with the British and often adopted their tastes and manners, whether in food, dress, gardening or photography. Far more could be said about this illustrious family and the transcultural dimensions of colonialism in Himalayan hill stations, but suffice to say, Ani Chokyi's decision to visit Paar's studio enabled her to fashion her own representation, even though the photographer still converted another of her portraits into a postcard and sold it merely as a depiction of a 'Tibetan Lady'.

The case of another visitor to the studio of Thomas Paar makes the processes of anonymization that were at work in colonial print culture even more explicit. To judge from the many times that his image was reproduced, ranging from a postcard circulated by the Society for the Preservation of the Gospel to an advertisement for Darjeeling's upmarket Woodlands Hotel, one Tibetan Buddhist monk seems to been propelled into the role of 'poster boy' for the town between the years 1890 and 1920 (he can be seen in illus. 29, for example). In all those iterations he is merely described as a 'Lama', a 'Tibetan' or a 'Himalayan' monk. Establishing his true identity can only be accomplished by consulting an original print from the Paar studio that was inscribed with the words 'Mongol Lama: She-rab'. Further research reveals that the monk's full name was Sherap Gyatso and he was actually a Buryat from Siberia. On arrival in the Himalayas in 1870 he had founded a Geluk

25 Thomas Paar, 'Bhutia lady', Darjeeling, around 1900, hand-tinted collotype postcard.

41

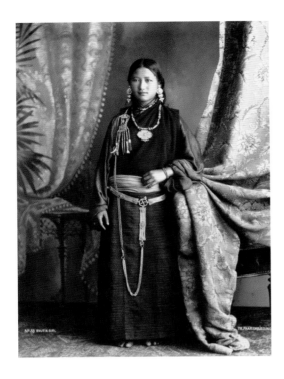

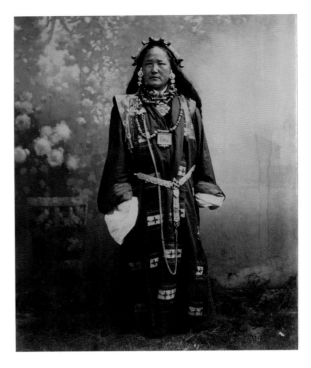

monastery at Ghoom, on the outskirts of Darjeeling, and in addition to functioning as a senior figure within the Tibetan Buddhist community like Laden La, Ugyen Gyatso and others, he was closely associated with the British and gathered information on their behalf. However, for the purposes of photographic studios and the consumers of prints, the biography of this significant individual was apparently irrelevant to their enjoyment of his image, and his primary duty was to stand as an archetype of his religion.

In fact it can be argued that apart from mountain scenery, it was Tibetan Buddhism, its associated communities and its material forms that were the chief foci of the visitor's gaze in imperial Darjeeling. As the *Illustrated Guide for Tourists* of 1896 proposed, an outing to the 'local village of the Bhooteas' to watch the 'absurd and grotesque lama dances which take place at the Buddhist temple' was considered an essential stop on their itinerary'.[48] It was also purportedly the perfect place to acquire 'native curios' and photographs of the local environs, some of which, in the opinion of the guide's author, were

'worthy of the best collections'.[49] High-quality photographic prints were clearly as marketable as the prayer wheels and skull bowls sold by Tibetan 'curio' sellers, and the likes of Thomas Paar set out to meet the demand. He certainly ventured out of his studio to photograph at the temple in the Bhutia Busty and, with the assistance of Laden La (pictured far right in layman's dress in illus. 31), arranged to picture its monks in the full paraphernalia of masked dance. The image was then retailed as a postcard and a large-format print. If further confirmation of the persistent popularity of Tibetan Buddhism as a subject of voyeuristic interest in British India were needed, we have only to consider the innumerable postcards generated in Darjeeling in which 'lamas' feature prominently or the official Bengal Tourism poster that went into circulation in the 1930s (illus. 33). By this time they had become the key signifier of the hill station's enduring appeal.

If photography aided and abetted the rise in popularity of Darjeeling as a tourist destination, it did so in close alliance with the idea that this was a place where Europeans (especially the British) could come close to Tibet in a doubly physical sense. From Darjeeling they could view the great snow-capped Himalayan barrier and imagine the land that lay beyond it.

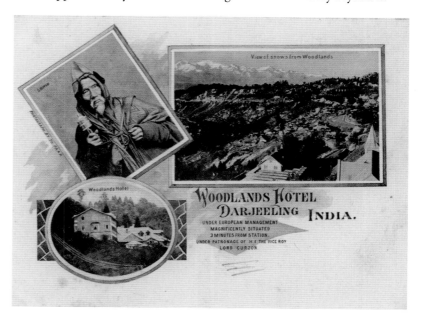

29 Thomas Paar, multi-view postcard advertising the Woodlands Hotel in Darjeeling, with Sherap Gyatso labelled as a 'Lama', early 20th century, collotype postcard.

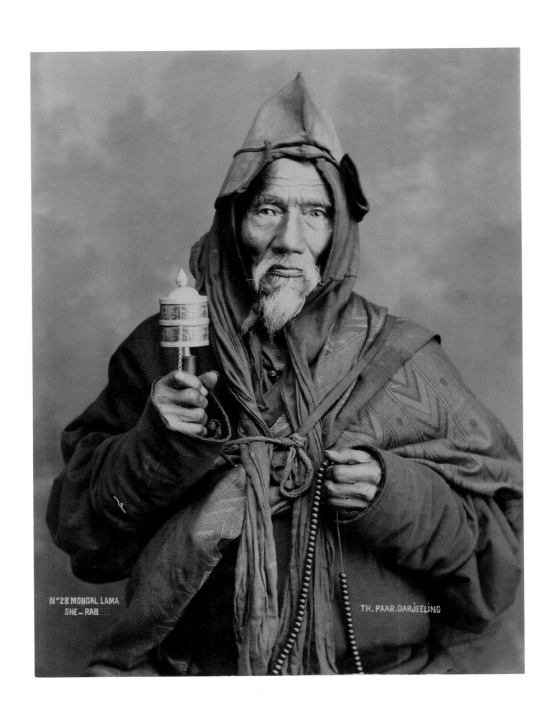

N°28 MONGAL LAMA
SHE—RAB

TH. PAAR.DARJEELING

30 Thomas Paar, 'No. 28 Mongol Lama: She-rab', Darjeeling, 1890s, albumen print.

31 Thomas Paar, 'No. 50 Divinity dance by lamas', Bhutia Busty monastery, Darjeeling, 1890s, albumen print.

They could also observe Tibetan Buddhists walking the streets with prayer wheels in hand, plying their wares as traders, or seemingly performing their culture purely for the benefit of others. They could then leave with photographic mementoes of their visit that could be displayed to entice friends and family to make a similar journey to a hill station where an accessible and attractive version of Tibet was available for all to enjoy.

Darjeeling therefore acted as a proxy for Tibet proper: a place where Tibetaness could be staged photographically for British consumption, while the land itself was closed to all but the audacious few. The most notable instance of this is manifested in the pages of a book published in 1902, *A Journey to Lhasa and Central Tibet*, which is an account of the secret missions conducted in 1879 and 1881 by the Bengali spy Sarat Chandra Das.[50] Like Philip Egerton and other Englishmen who had preceded him, Das was

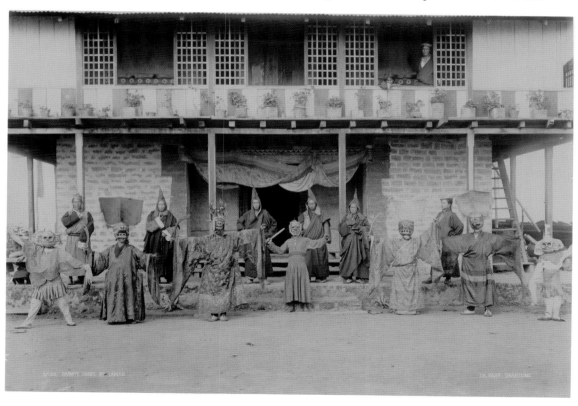

TIBETAN MENDICANT T. 2.

32 Unknown photographer, 'Tibetan mendicant', Darjeeling, around 1900, hand-tinted collotype postcard.

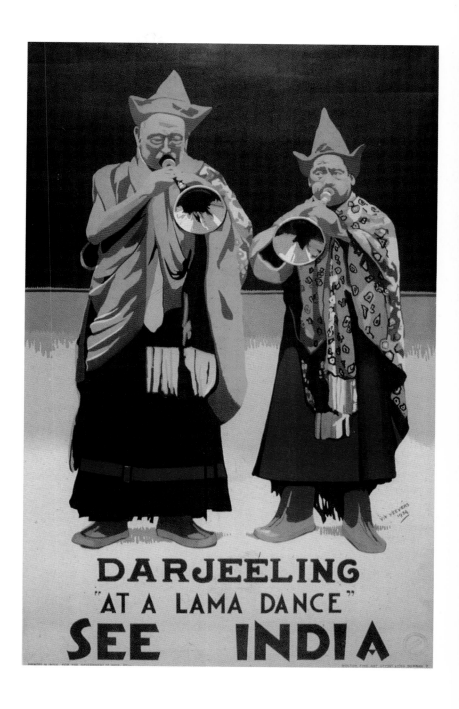

33 Bengal Tourism, 'Darjeeling "At a Lama Dance": See India', 1930s, poster.

instructed by the British government to gather intelligence about Tibet, map its shape and pave the way for greater access to the country from British India. As a South Asian disguised as a Tibetan monk, Das had far greater success in this endeavour than his white counterparts and he even managed to travel as far as the capital, Lhasa. However, when the Tibetan authorities discovered that their country had been breached by an undercover agent under the employ of British India, they severely punished all those who had assisted him.[51] As a result, Das's official report was embargoed and he was prevented from making his observations in Tibet public. Twenty years were to pass before they could be released, in a volume published by the leading British distributor of works of colonial fiction and exploration: John Murray. Although Das was an experienced photographer and shared his skills with a high-ranking Tibetan monk (see Chapter Three), the covert nature of his work meant that he was unable to create any pictures while in Tibet. His publishers, however, were keen to punctuate the voluminous text of *Journey to Lhasa* with illustrations that would meet the expectations of customers who purchased an extremely rare, first-hand account of Tibet. In the absence of photographic documentation of his path-breaking trips, Das and his

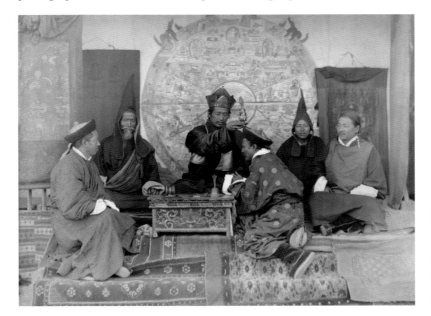

34 Sarat Chandra Das, 'A Tibetan Ceremony', from *Journey to Lhasa and Central Tibet* (1902). Sherap Gyatso is at back left with pointed hat and distinctive facial hair. Ugyen Gyatso is seated in front of him. Photographed in Darjeeling in the 1890s.

35 Sarat Chandra Das, 'Disposing of the dead. Scene at a cemetary [sic]', albumen print created in Darjeeling in the 1890s for publication in *Journey to Lhasa and Central Tibet*, preserved on card at the Royal Geographical Society and inscribed in various hands. (Sherap Gyatso is on the far right in a pointed hat.)

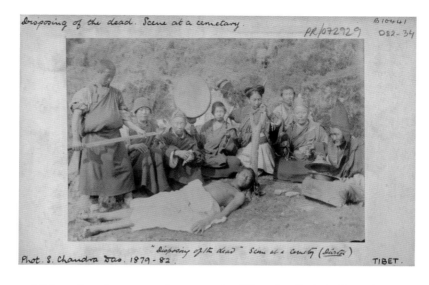

publishers therefore resorted to recreating Tibet visually in India and, more precisely, in Darjeeling.[52] Having retired there after his travels on behalf of the Imperial intelligence service, he called upon his friends and neighbours to create a cast of suitably Tibetan-looking characters for his photography. By placing them in front of appropriate Buddhist buildings (including at the Bhutia Busty) he sought to reconstruct an authentic impression of Tibet. Das's Buddhist acquaintances dutifully acted out the scenes he had witnessed and enacted some of the most distinctive features of Tibetan culture for his camera. The book contained illustrations of a marriage ceremony, sky burial, worship in a temple, banditry, 'black hat' *cham* dances and so on. Among the many intriguing features of these visual fictions is the fact that the figures who enacted them included Sherap Gyatso, Ugyen Gyatso, Laden La and other Buddhists from Darjeeling who were informants for the British. In addition to this service, they became central players in the staging of Tibet in the Indian Himalayas, and Darjeeling emerged as the primary site where photographic commodities designed for a British public eager to consume Tibetan exotica was produced.

Throughout this chapter I have argued that (apart from Egerton's rock bridge in western Tibet) the earliest photographs of Tibet and Tibetans were actually created in British India and often directly under the auspices of the

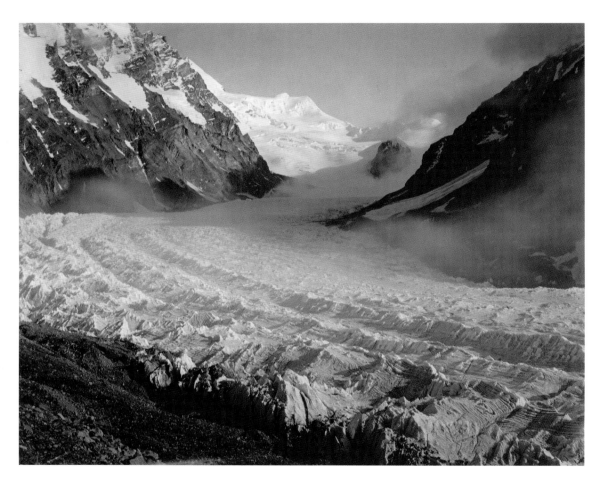

36 John Claude White, the source of the Teesta River: a glacier on the Sikkim–Tibet border, 1902, albumen print.

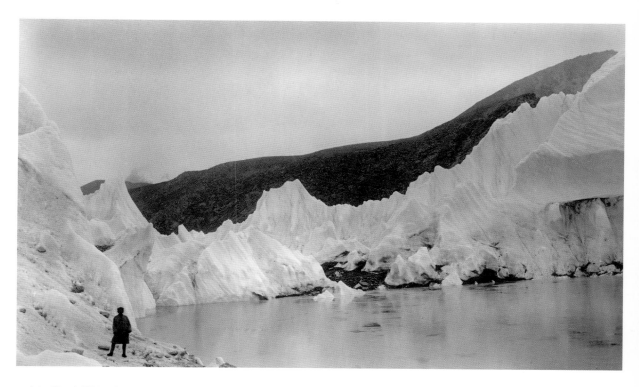

37 John Claude White, 'Ice
sculpture in the Langto valley',
1902, albumen print.

colonial regime. In my final case study, these topics recur, but the boundary between imperial documentation and photographs as artefacts of commerce becomes even more indistinct. John Claude White was a leading figure in the Indian civil service who spent much of his career in the Himalayas and Tibet. He first travelled to Sikkim in 1888 when war had broken out between the Sikkimese and the Tibetans. Following British intervention in this battle, Sikkim was effectively incorporated into India and White was offered the newly created post of Political Officer for the area.[53] During the course of his service there, White began to develop an interest in photography and to concentrate in particular on the landscapes that surrounded him. Thus, like Egerton, Bourne and others who worked at the western end of the Himalayan range, White became adept at conjuring sublime images of the scenery in its eastern reaches. He, too, experimented with photography at very high altitudes in the area approaching the loftiest peak in the region – Mount Kangchenjunga – but he did so in collaboration with Theodor Hoffmann of the Johnston & Hoffmann photographic firm from Darjeeling. As he and Hoffmann wrote in 1892 in an essay for the Royal Geographical Society journal, the two men struggled with the harsh conditions but ultimately succeeded in 'getting some excellent pictures' of glaciers, caves, ice bridges and other beautiful 'curiosities of nature's architecture'.[54] It seems that White then sold many of his negatives to Johnston & Hoffmann, since existing prints from the expedition are usually attributed to the company rather than to either of the individuals concerned. Even if White thereby lost control of the authorship of his efforts, he had certainly benefited from working alongside a professional photographer and had become one of the most accomplished amateur landscape photographers in northeast India.[55] These skills would prove invaluable in the next phase of his career, beginning in 1903, when White participated in the first British military expedition to infiltrate Tibetan territory, serving both as deputy to its leader, Francis Younghusband, and as the official mission photographer. He would thereby play a leading part in an invasion of Tibet that was facilitated by two of the most powerful technologies of the British Empire: the gun and the camera.

The Opening of Tibet to Photography

If the nineteenth century presents us with a tale of repeated failures to photograph Tibet, the beginning of the twentieth century marks an upturn in the fortunes of those outsiders who sought to capture it with the camera. This change was largely initiated during a brutal incursion into Tibetan territory by one of the most powerful global players with interests in controlling access to it: Imperial Britain.

With thousands of troops and weapons at his command, the mission led by Francis Younghusband in 1903–4 enabled British men to enter Tibet proper en masse and to document it photographically for the first time. Contemporary accounts of the expedition repeatedly characterized it as a triumphal 'unveiling' in which the teasing courtesan of Tibet finally revealed her true face to the outside world.[1] This insidious Orientalist metaphor severely downplays the force that was required to penetrate Tibet and the negative impact Younghusband's actions had on the lives and property of Tibetans, but it also alludes to the sense in which the viewing of a previously empty space on the imperial map was among the mission's primary objectives and outcomes. When some of the hundreds of pictures that resulted from the mission were printed in newspapers and monographs, they served to furnish the homes and minds of the British public with imagery of a remarkable, newly discovered territory. And yet, despite these photographic revelations, the expedition only triggered further efforts to unveil Tibet with the camera as the twentieth century progressed.

In the early decades of that century a number of individuals from Europe and North America embarked on personal quests to venture within the boundaries of the country and to be able to trumpet their unique achievements

via the services of photography. They would set out to overturn Tibetan resistance to the prying lens of the camera and to infiltrate the territory that their forebears had been denied. These characters declared themselves to be, with not a little hyperbole, the first American to visit Tibet, the first European to reach Lhasa, the first foreign woman to traverse the Tibetan plateau, the first Caucasian to be dubbed a 'White Lama' and so on. Between 1910 and 1950, variations on the pioneering theme abound in the publications and publicity generated by those who succeeded in breaching the Tibetan frontier. For all of them, photography was enlisted to authenticate their claims and to illustrate the books, newspaper articles and lectures in which they informed the world about the extraordinary nature of the landscape, people, religion and culture of Tibet. However, in several instances there was often more than a hint of self-promotion in the way that photographs were used to articulate tales of adventure. As a result, the pictures frequently tell as much about their authors and their intended audiences as they do about their ostensible subject, Tibet.

But before analysing this development further we must briefly return to the inception of attempts to assail Tibet photographically, a project that had international dimensions and political ramifications in the late nineteenth century. Prior to my identification of Egerton's photograph of 1863, the title of first photographer of Tibet has generally been assigned to the French prince Henri of Orléans. During a journey covering more than 14,400 kilometres of eastern Asia in 1889–90, Henri actually reached the Tibetan plateau a decade before the close of the century.[2] The expedition was led by Pierre Bonvalot, who embarked from France with the explicit aim of exploring regions of Central Asia and China that had not been visited by Europeans before. Bonvalot and his team planned to pursue a route through the Gobi and Lop Nor deserts that would culminate at the Tibetan capital, where they aimed to become the first group of foreigners to photograph it. Much of this ambition was realized, but Tibetan officials prevented the party from reaching their ultimate goal, Lhasa. Nevertheless, the photographs taken by Henri in the Changthang, a vast plain extending across the north and west of Tibet, and others documenting its eastern regions are unprecedented and important because they constitute the earliest photographic record of Tibetans in landscapes and locations that are thoroughly Tibetan (illus. 38).

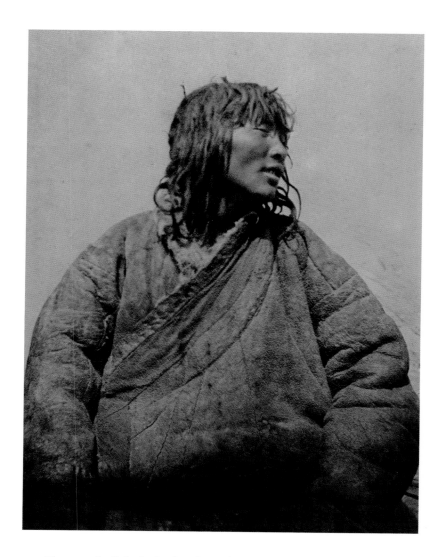

38 Henri of Orléans, young Tibetan man in sheepskin coat, Changthang, Tibet, 1890, albumen print.

There can be little doubt that the uncharted territory of Tibet posed one of the greatest challenges to European adventurers of the Victorian period. Perhaps the most renowned figure among them, the Swedish explorer Sven Hedin, made repeat journeys to Tibetan country from 1893 onwards, during which he managed to map large expanses of its northern and western reaches.[3] However, when he headed for the capital in 1900 and again in 1901, he too was not allowed to proceed. The large collection of photographs taken by Hedin during his four missions therefore documents substantial swathes of

Tibet, but not its most prized destination (for an example see illus. 39 below). It seems that the distinction of becoming the first to photograph Lhasa would be granted to a Russian national. Gombojab Tsybikov was a Buryat from Transbaikal who had been raised as a follower of Tibetan Buddhism. His religious affiliation, coupled with the fact that he spoke Tibetan and travelled with a group of other Russian Buddhists, apparently eased his entry into Lhasa.[4] However, Tsybikov was also a graduate of the Oriental Institute at St Petersburg and had been sponsored by the Russian Geographical Society to document the lives of Tibetans in their most sacred city. Over the course of several months in 1900 and 1901 he discreetly gathered information and took photographs, including of the magnificent building – the Potala, the palace of the Dalai Lamas – that dominated the Lhasa skyline. His success with photography meant that on his return to St Petersburg, not only Russian but British and American learned societies were keen to publish an account of his journey to the heart of Tibet and to embellish it with illustrations. The rarity of Tsybikov's pictures even led to a feature in *National Geographic*; its minimal text but revelatory imagery set a benchmark for the presentation of travel photography in that journal.[5] In the meantime, Tsybikov's linguistic and

39 Sven Hedin, view from Hedin's camp in the Changthang, northwest Tibet, 1901, gelatin dry plate.

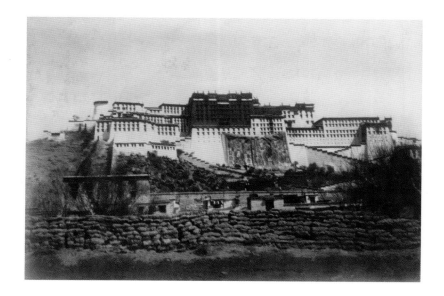

diplomatic skills were also much in demand. In 1904 the Buryat was called
upon to act as the translator for the 13th Dalai Lama when the Tibetan leader
sought temporary exile in Mongolia. He had decided to take refuge in Urga on
receiving news that the British army was marching towards the citadel of his
authority: the Potala palace.

Military Photography

As the residence of the Dalai Lamas since the seventeenth century and a
structure where the administrative, religious and political functions of Tibetan
theocratic governance were housed, the multi-storeyed, thousand-chambered
Potala was by far the most imposing and important building in the whole of
Tibet.[6] It was therefore no small matter as to which of the foreign powers with
interests in the country would be the first to visit and photograph it. The fact
that it was a Russian with connections in academia and government in his
homeland who had achieved this was therefore highly significant and the
publication of Tsybikov's pictures in leading international journals meant
that they did not escape the notice of individuals in powerful quarters in

Europe, the United States and India. In the early years of the twentieth century the 'Great Game' was at its height: Britain and Russia were vying for supremacy in Tibet and seeking to prise control of it from the hands of the Qing dynasty in China.[7] The idea that the Russians might win this contest and thereby gain ready access to the northern border of British India was of particular concern to George Nathaniel Curzon, the man who had become viceroy of India in 1899. Although a passionate Orientalist and an admirer of many aspects of the heritage of the subcontinent (he is said to have arranged for the conservation of the Taj Mahal, for example), Curzon took a dim view of Tibet, describing it as 'a miserable and monk ridden country'.[8] And yet the British had been determined to ascertain both the extent of Tibet's landmass and the depth of its natural resources since the mid-nineteenth century. All manner of colonial officers, from cartographers to intelligence agents, had been assigned to this endeavour, but official permission to access the country had been repeatedly denied and, as a consequence, photographs of Tibet remained unavailable to them. How it must have pained the viceroy to learn not only that a citizen of a competing nation had been to Lhasa in 1900, but that he had produced photographic evidence of his visit. Even worse, the Tibetan government continued to refuse to countenance any communication with British India. With imperial pride seriously affronted and matters of strategic importance at the fore, Curzon resolved to send a military mission to Tibet under the leadership of Francis Younghusband. Armed with the most up-to-date weaponry and a massive phalanx of potential combatants, in 1903 Younghusband's force became the first European contingent to pierce the borders of Tibet and, in essence, to invade it.[9]

Over the course of eight months, the British army advanced on Lhasa, eventually reaching the city at the beginning of August 1904. Though the mission had begun with supposedly peaceful intentions, it soon deteriorated into a series of bloody battles along the route, during which the British incurred only modest losses, while it is estimated that the Tibetans suffered close to 2,000 casualties. In addition to cannons hauled over the Himalayas on carts, the British utilized the most cutting-edge ordnance of the Edwardian era, the Maxim machine gun, and directed it to deadly effect against the Tibetans, whose only source of defence came from antiquated matchlocks and amulets blessed by Buddhist monks. The grim effects of this severe

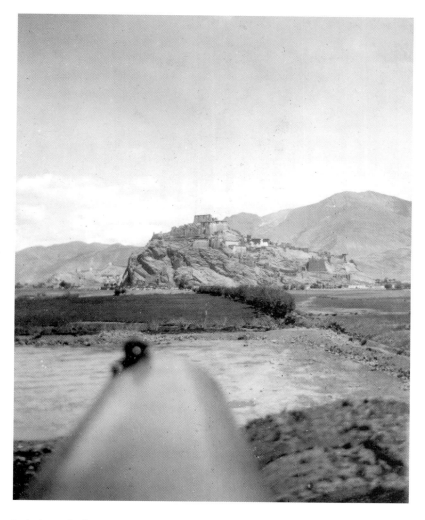

imbalance in firepower was particularly acutely felt during a protracted fight at Gyantse, a trading post and site of a major monastery in southern Tibet. As Arthur Hadow, one of the officers responsible for the deployment of the Maxim, wrote following its conquest: 'It was a rather horrible affair as the slaughter was terrible.'[10] A photograph he took from the British encampment shows how he trained both his weapon and his camera on the *dzong*, the fortress and administrative powerhouse of the town. Along with many of his

comrades, Hadow had ensured that he could set off for Tibet with a small hand-held camera in his luggage. The picture therefore confirms that Younghusband's mission was not only the first large-scale military operation against the Tibetans, but the first occasion when substantial numbers of British men were able to photograph within Tibet proper. It also makes it quite clear how the former facilitated the latter.

These factors are also evident in the pictures created by John Claude White, who, as the official mission photographer, was tasked to record it in full. In order to meet this requirement he was provided with several cameras (including a massive and heavy panoramic camera) and a team of porters who were specifically allocated to assist him. With his previous experience in the high Himalayas, White was already adept in topographical photography. Many of his photographs could therefore be categorized as landscape views, resulting from the attention of his panoramic lens as it scanned the wide plains of

42 John Claude White, Khampa *dzong*, 1904, platinum print.

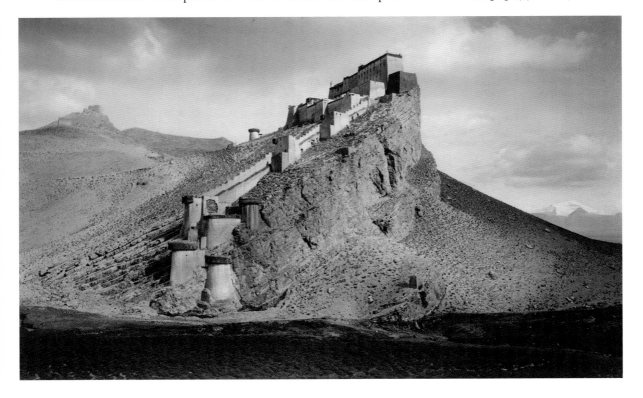

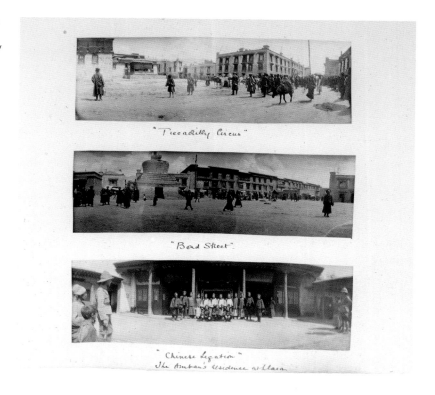

"Piccadilly Circus"

"Bond Street"

"Chinese Legation"
The Amban's residence at Lhasa

southern Tibet or swept down the valley of the Kyichu River on the approach to Lhasa. But if these compositions exude the rarefied atmosphere of the sublime, it is frequently punctured by a phalanx of British troops marching through the Tibetan countryside with their weapons and equipment in tow. Unlike Samuel Bourne's Himalayan scenes, these are landscapes where men are by no means subordinate to nature: when armed and British, they conquer it.

John Claude White also photographed the buildings abandoned by Tibetans as Younghusband's force approached. He converted what he called the 'impudent' impregnability of their facades into subjects of aesthetic contemplation for British observers (as is evident in illus. 42 opposite).[11] This procedure began in earnest in the aftermath of the mission when White's official visual record was published in two editions under the title *Tibet and Lhasa*.[12] Dozens of prints made from the glass plates he brought back from Tibet were bound in handsome red leather volumes and presented to the

leaders of the mission, as well as to senior members of the British government from Lord Curzon downwards. Further copies were then made available for the public to purchase. White provided a commentary for them with captions aimed at justifying Younghusband's actions and vilifying those of the Tibetans. It is therefore easy to read his photographs as documents of triumphalism, in which their content as well as their format – especially the panoramas of the Tibetan countryside with their distinct air of surveillance – reflect colonialist supremacy in visual and military terms. However, such a reading may overlook some of the finer details of history, and overplay the hegemonic and official aspects of the deployment of photography. The fact that White's Tibet prints also circulated in less elite contexts, where they were inscribed with more intimate messages, needs to be taken into account.

In the albums created by lower-ranking troops after their return from Tibet, the products of White's government-sponsored photography are often intermingled with prints developed from the soldiers' own cameras. Among them, Lieutenant G. J. Davys gathered material from eleven of his comrades to compile a large volume in which he pasted hundreds of images and penned a rather different interpretation of events in Tibet from that outlined in White's presentation.[13] In their positioning within the visual narrative and intermingling of small format prints alongside White's grand panoramas, some unsettling incongruities arise. One page includes a picture labelled 'The dead after a fight. Convoy passing through the bodies'. It is pasted directly alongside a snapshot of four British soldiers enjoying themselves 'fishing in a stream at Tuna', the site of another massacre. Distasteful as it may now appear, a relaxed, even playful tone is commonly adopted in the commentaries written by the lower ranks around their photographs. Another Younghusband mission album created by a member of the Royal Fusiliers includes two of White's scenes of streets in Lhasa's historic trading centre – the Barkhor – labelled as 'Piccadilly Circus' and 'Bond Street' (illus. 43).[14] Such inscriptions indicate that British troops domesticated the strangeness of the Tibetan capital by comparing it jovially (or perhaps even mockingly) to the famed shopping avenues of London. Of course, when crafting albums destined only for the private enjoyment of friends and family, soldiers inserted text and manipulated the reception of their pictures accordingly.

In fact the process of translating the experience of Tibet through photographs had begun well before the troops even returned home. In addition to the sheer number of cameras that were focused on Tibet for the first time in 1903, Younghusband mission photography is notable for the fact that it was distributed and shared with others back in India and Britain even while it was underway. The postal facilities that had been set up along the route from India ensured that negatives could be processed there or mailed directly back to Britain with astonishing speed. Some soldiers therefore took the opportunity to enhance their military salaries by posting pictures of Tibet to London and Calcutta for publication in newspapers, in which they were used to illustrate reports on the progress of the mission and for multi-page features hailing the extraordinary sights 'unveiled' by British forces. This procedure marks a significant shift in the history of the visual representation of Tibet, as mass reproduction in newspapers enabled depictions of the country to land on breakfast tables in homes throughout India and the United Kingdom. The Younghusband expedition thereby installed Tibet within the 'imagined community' of transnational Imperial Britain, making it an attractive feature of popular print culture for millions to consume.[15]

Alongside this more public mode of viewing photographs of Tibet, Younghusband's soldiers were also activating them in private, even intimate,

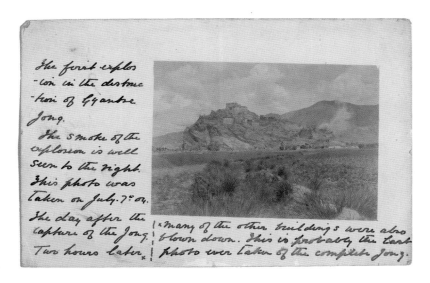

44 G. J. Davys, postcard from Gyantse, 1904, silver print on card.

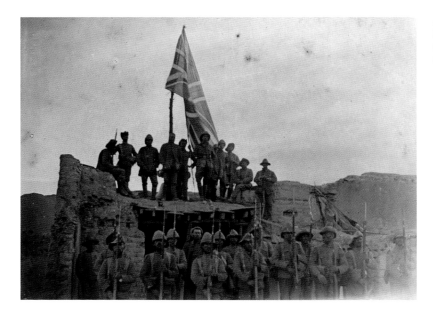

contexts. Prints served as an invaluable vehicle for communicating their personal experiences, since a commentary could be written on the reverse detailing the battles they had participated in and the challenges they had overcome. Lieutenant Davys even went so far as to have a postcard made showing 'the first explosion' during the British bombardment of Gyantse fort. On it he wrote: 'This is probably the last photo ever taken of the complete Jong [sic]' (illus. 44).[16] The postmark tells us that he sent this card to a Miss Irvine of Blackheath, London, on 9 November 1904, once he was safely back in British India. Was she a lover, a cousin, a friend? Who knows, but what is certain is that Davys was not alone in using his photographs to memorialize a conquest and elicit admiration for his role within it. Many of his comrades distributed prints among relatives and confidantes so that these people could imagine the trials and tribulations that the troops had endured and celebrate what they had achieved. George Rayment of the Royal Fusiliers even thought that a small album of Tibet photographs would make a suitable gift for his sister on her birthday on 18 March 1905.[17] It begins and ends with his smiling portrait, taken in India before and after the expedition, as if to prove that he had survived with both stiff upper lip and good humour intact. In between,

Rayment's handwritten notes on his photographs chart the course of the force and culminate with a picture of his battalion hoisting the Union Jack at the highest town 'taken' by them in Tibet (illus. 45).

For critics in parliamentary and press circles back in England, it was precisely the taking of Tibetan land, lives and property that made the Younghusband mission of questionable merit in terms of both its ethics and its impact on international relations.[18] On the other hand, supporters of Younghusband's project were keen to argue that among its principal achievements was the photographic record it had generated. In fact when Laurence Waddell's heavily illustrated book about the expedition was published in 1905, a reviewer remarked that his 'most useful' photographs 'flatly contradicted' those who asked whether 'any tangible result has been secured by the expedition to Lhasa'.[19] Edmund Candler, a reporter for the *Daily Mail* who had been embedded with the troops throughout, concurred when he announced that the arrival of British cameras in the Tibetan capital meant there were 'no more forbidden cities which men have not mapped and photographed'.[20] For Younghusband's admirers, the mission had succeeded in fulfilling many of Curzon's objectives. It had forced the Tibetan government into a trade agreement that granted the British access to their country in the future, while denying the same to the Russians. It had also ventured deep into the heartland of Tibet and overturned decades of Tibetan resistance to imperial photography.

I have emphasized the circulation of Tibet photographs in this discussion because it relates to two questions that inform my approach more generally: what motivates individuals to take photographs and what role do the resulting images play for their viewers? In essence, photography is a technology of replication. From the instant of its creation, a photograph has the potential to be reproduced on innumerable occasions and to enter the 'visual economy' in a multitude of ways.[21] Of course, not every negative is developed and not every print is published. Many pictures never see the light of day or are stored in archives for decades without ever being consulted. Others however are constantly reproduced to perform in a variety of public and private settings, as was and remains the case with John Claude White's view of Khampa *dzong* or Frederick Spencer Chapman's classic portrayal of the Potala palace (illus. 46). As objects with social lives, photographs (including some of great age)

retain their potency long after the date of their origination and act as stimulants to conversation or elicit memories within the networks in which they are distributed.[22] Since this is a book about a particular place, it is also worth reiterating that when taking pictures, colonial-era photographers-cum-explorers are often highly conscious that they are documenting people and environments that others may not have seen and may never themselves have the chance to gaze upon. Their work arises from privileged access to different worlds and different lives, but is often directed towards sharing that experience with viewers from similar backgrounds to their own. For the photographer, a print of Tibet can therefore function as a memento of sites in which they were physically present, while also serving as an authenticating device and an artefact that transmits the semblance of having travelled to remote locations for others who view it.

Photographs therefore function in a variety of registers according to the intentions of their makers and the social, economic and cultural contexts in which they are received. Since they famously absorb an excess of information, the products of the camera cannot readily be assigned a singular 'meaning' and they remain open to interpretation, irrespective of the objectives of their creators. However, some photographers undoubtedly compose their work according to predetermined criteria. The 'ethnographic' is just one such mode, and it has a specific ambition and style that is closely associated with the rise of anthropology as a fieldwork-based discipline in the early twentieth century.[23] In ethnographic photography, the visual data indexed in an image may be intended to supplement or even eclipse the textual record. It also requires a very special kind of regard on the part of the photographer and a particular kind of access to the subject depicted. Such photography usually entails long-term involvement with a particular community and the personal skills – social and linguistic, as well as technical and aesthetic – that can generate an enhanced degree of intimacy with its members. I raise these points at this juncture since they allow us to unpack some important distinctions between the various forms of Tibet photography presented in this chapter. In it we may discern a gradual move away from the distancing imperial gaze towards increasing degrees of photographic proximity with Tibet and Tibetans, even if the overriding intention of photographers remains one of capture and revelation.

Since the pictures taken by British men in Tibet in 1903–4 were crafted in a military context when the troops were on the march and few of them had the ability, opportunity or desire to communicate with Tibetans, we can safely say that they are by no means intended as ethnographic documents. In general, when focusing on Tibet as place they tend towards the landscape genre, or when detailing the conditions of camp life for the troops, towards a British vernacular style of documentation. Portraits of Tibetans barely feature, since the closest most British soldiers came to the bodies of their enemies was when walking through a corpse-strewn battlefield. Hadow's view of Gyantse *dzong* reiterates this general point: a wide chasm lay between the guns and cameras of the British and their targets, Tibet and Tibetans. In the absence of close contact

46 Frederick Spencer Chapman, Potala palace photographed from the monastery at Chakpori, Lhasa 1936, from a nitrate film negative.

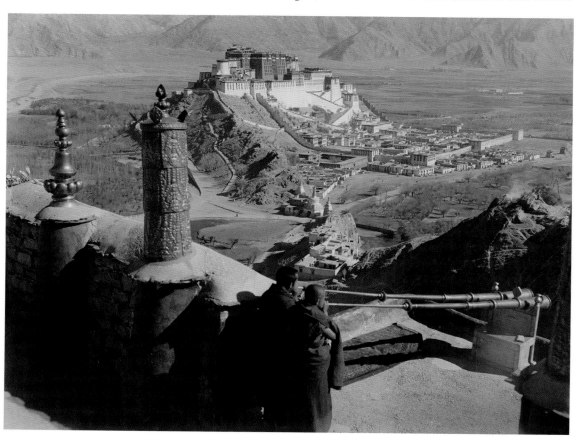

with Tibetans or knowledge of their religion and culture, the photographic output of members of the Tibet mission could be seen as voyeuristic at best, or at worst simply as documents of a British triumph over a previously unvanquished country. Examining them today teaches us relatively little about Tibet and far more about the last gasps of British imperialism in Asia.

Photography and the Frontier Cadre

If we turn our attention to a man who studied and worked in Tibet in the era following the Younghusband expedition, a rather different type of photographic engagement with it emerges, in which some of the characteristics of ethnographic photography are present. This can be detected in the activities of Charles Bell, a 'frontier cadre' who specialized in establishing cross-border relations between Tibet and British India.[24] In 1904 Bell was placed in charge of Chumbi, a Himalayan valley connecting India and Tibet that had been ceded to the British as part of the treaty signed in Lhasa that year. His assignment there marked the start of an illustrious career in the civil service, during which

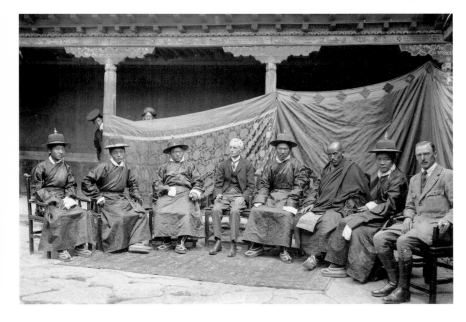

47 Rabden Lepcha, Charles Bell (centre) photographed with some of the guests he had invited to a performance of the Tibetan opera *Ache Lhamo* in Lhasa, 1921, from a gelatin dry plate.

48 Charles Bell or Rabden Lepcha, crowds gather beneath enormous offerings made of butter for *monlam chenmo*, the great prayer festival in Lhasa, 1921, from a gelatin dry plate.

Bell became renowned as a specialist in Anglo-Tibetan relations and was ultimately knighted for his services. Over the course of his career he gained many accolades, such as serving repeatedly as chief Political Officer for Sikkim, Bhutan and Tibet; becoming a close confidante of the 13th Dalai Lama; and spending the best part of a year in Lhasa in 1921. Having immersed himself in Tibetan culture for many years and achieved fluency in the language, Bell could justifiably assert that by the end of his life he had become 'in a large measure Tibetanised'.[25] The good relations he established with leading figures in Tibetan society also garnered compliments from them, as one official reportedly stated: 'When a European is with us Tibetans we feel that he is a European and we are Tibetans; but when Lönchen Bell is with us, I feel that we are all Tibetans together.'[26] (*Lönchen* is a Tibetan title usually only given to senior ministers in the Tibetan government.)

Alongside his diplomatic duties, Bell created many photographs. His diaries and notebooks reveal that he was acutely conscious of the need to keep a visual

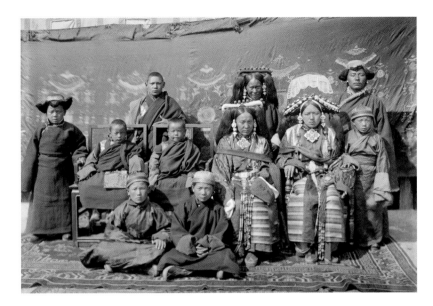

49 Charles Bell or Rabden Lepcha, members of the Ragashar family, one of the noble families of Lhasa, 1921, from a gelatin dry plate.

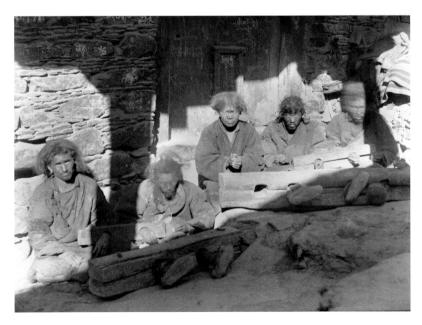

50 Charles Bell or Rabden Lepcha, convicted criminals outside the prison near the Potala palace, Lhasa, 1921, from a gelatin dry plate.

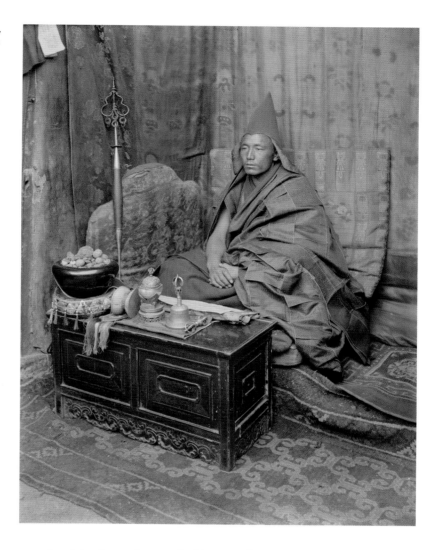

51 Charles Bell or Rabden Lepcha, a Geluk monk in Lhasa, 1921, from a gelatin dry plate.

overleaf:
52 Rabden Lepcha, a Golok couple visiting Lhasa on pilgrimage, Lhasa, 1921, from a gelatin dry plate.

53 Rabden Lepcha, The 'Trup-tor lama', a Nyingma priest, with the instruments of his religious practice, Lhasa, 1921, from a gelatin dry plate.

record and that he saw it as a valuable asset when researching, writing and promoting interest in Tibet to British audiences.[27] This was especially the case after 1918 when Bell first took temporary leave from his civil service role and began to analyse the material that would eventually appear in four books, including *The People of Tibet* (1928) and *The Religion of Tibet* (1931). The notes he used to prepare those monographs show that he sought to document every

71

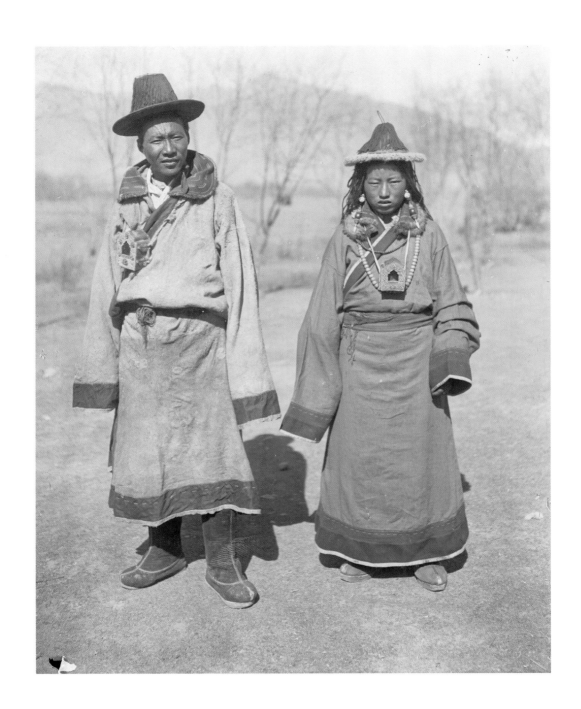

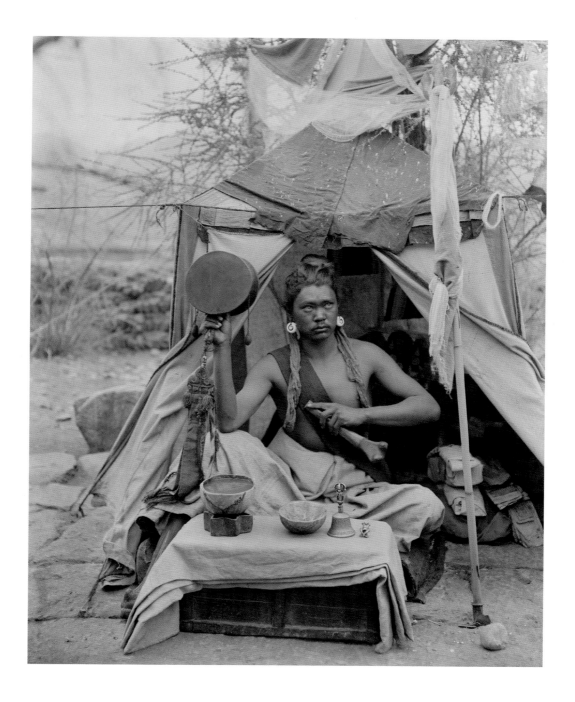

conceivable aspect of Tibetan culture, from the symbolism of major religious ceremonies to the fine details of domesticity – such as, for example, the loving attention Tibetan women paid to plaiting their husbands' long hair. Entries in his notebooks intermingle information provided by his high-placed Tibetan friends (including the 13th Dalai Lama), with comments about whether he had managed to acquire a photograph to illustrate either their observations or his own. Since Bell was preparing volumes designed for a British readership hungry to learn more about Tibet, he seems to have been only too aware that they required very specific sorts of illustrations. For example, when preparing a discussion about Tibetan social structure, he sought to depict the aristocratic elite as well as beggars and criminals on the margins of society (illus. 49, 50). Studying Bell's collection of glass plates at the Pitt Rivers Museum in Oxford makes it clear that it was when he had the chance to spend a year in Lhasa in 1921, at the invitation of the 13th Dalai Lama, that Bell acquired many of the images that would appear in his publications. They would also be used in other kinds of presentations, such as a lantern-slide lecture that Bell gave at the Royal Geographical Society in London in

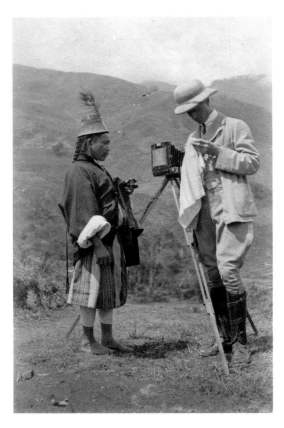

54 Edith Kerr, Rabden Lepcha and Charles Bell with camera on a tripod, near Sang, Sikkim, 1913, gelatin silver print.

1924.[28] Surviving records for that talk indicate that he sometimes had great difficulty in getting hold of the correct pictures, however. During his stay in the Tibetan capital he was easily able to procure portraits of lay people from the central areas of Tibet, or of the Tibetans he knew personally, but when it came to creating a slide of a Golok couple who were visiting from eastern Tibet, Bell wrote that they had been highly resistant to being photographed and only agreed to do so in the presence of Bell's Sikkimese orderly, Rabden Lepcha. A similar difficulty arose when Bell required a picture of a Nyingmapa – a follower of the oldest school of Tibetan Buddhism – for publication in *The Religion of Tibet*. Once again, it was only through the services of Rabden Lepcha that this could be achieved. Bell's diary entry for 17 May 1921 gives a telling insight into the creation of a photograph through the combined efforts of

55 Hugh Richardson, the *doring* (edict pillar) outside the entrance to Tsurphu monastery, 1946 or 1950, from a nitrate film negative.

multiple parties, in this case of an English civil servant, a Sikkimese Lepcha and a Tibetan tantric adept (not to mention the technological agency of the camera). Bell wrote:

> Rabden has, at my request, recently taken a photo of a Trup-tor priest. The Trup-tor told him 'Nobody has succeeded in photographing me, though several have tried, for I have a god (*lha*) inside me'. Then, as an afterthought he added, 'still, if your photo comes out well, you might

give me a copy'. It has come out very well and Rabden has given him a copy accordingly. He was very pleased with it, has had it framed . . . and put it up in his room. He made no further remark about the god inside him.[29]

Following this success in overturning the priest's scruples and his acceptance of a photographic gift, Bell increasingly deputed Rabden to take photographs in Lhasa on his behalf. On other occasions the two men worked together, as they did for a series of portraits of the 13th Dalai Lama that were the first to be taken in his summer residence, the Norbulingka.[30]

Charles Bell thus had the linguistic and diplomatic skills of an ethnographer and the close personal relations with individuals from all levels of Tibetan society that could enhance the range and nature of his photographs. The collection of images he accumulated has a more empathetic quality than those of previous British photographers, but that tone could not have been achieved without the skill and character of Rabden Lepcha. We will pursue the question of how Tibetans and individuals from other parts of the Himalayas began to work as photographers in their own right in the next chapter, but for now let me summarize the importance of Bell as a commissioner and creator of photographs.

57 Hugh Richardson, the Nechung oracle going into trance at his monastery outside Lhasa, 1937, from a nitrate film negative.

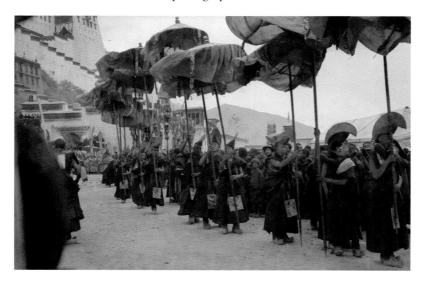

56 Hugh Richardson, the *sertreng* (golden procession) of monks at the foot of the Potala Palace, Lhasa, 1949 or 1950, from a nitrate film negative.

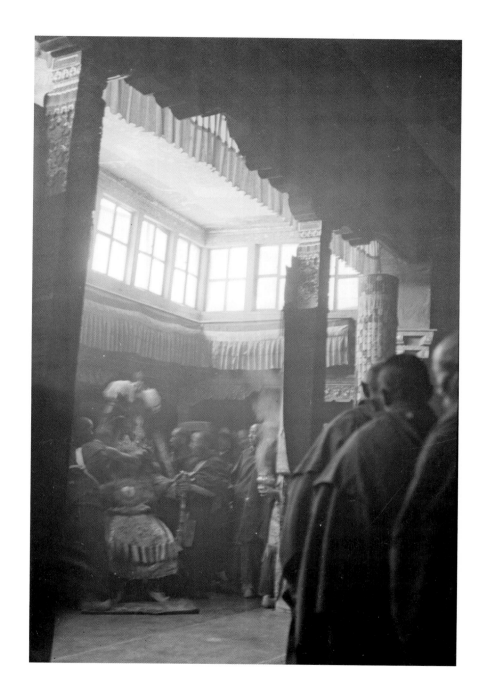

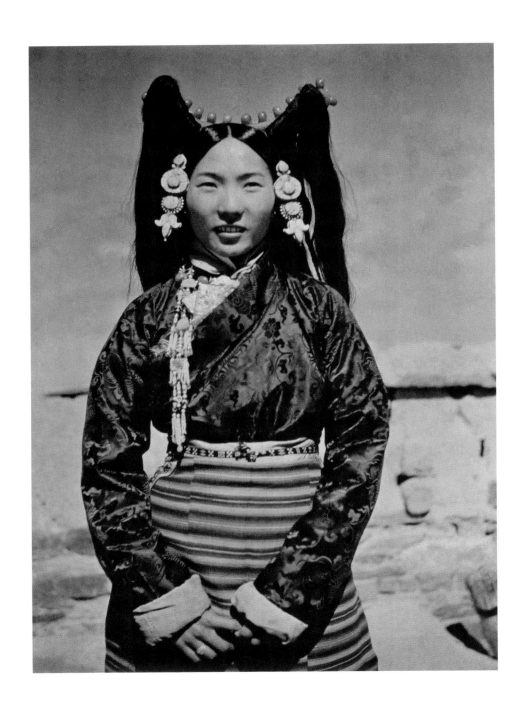

Bell's intentions were twofold: in lectures and publications Bell used images to illuminate Tibet's history and culture and to demonstrate that these were entirely distinct from China. As a 'frontier cadre', scholar and author, he harnessed the power of photography to defend the interests of the country he loved against the threat of her powerful neighbour to the east. For him, the visual was decidedly political.

By collaborating with Rabden Lepcha, Bell's photographic style began to bridge the chasm between photographer and subject that had been so apparent in earlier British photography. Although undoubtedly an heir to that colonial visual legacy, Bell was an important transitional figure in the lineage of British civil servants. In the decades that followed his retirement, other men assumed the mantle of Political Officer for Sikkim, Bhutan and Tibet, and they all took photographs, indicating that the creation of visual documentation had become a standard requirement of the position. Among Bell's successors, Hugh Richardson came closest to achieving a similar level of sensitivity in his photography, since he, too, was a noted scholar of Tibetan language and history. When he ceased his official duties in 1950, Richardson also wrote up some of the rich knowledge he had acquired in Tibet, which he then published in a number of books.[31] However, his publications did not draw as extensively on his photographic endeavours as Bell's had done, and it was only posthumously that his account of the *Ceremonies of the Lhasa Year* was printed with his own illustrations.[32] It is therefore only by examining the prints and negatives that were deposited at the Pitt Rivers Museum after his death that we can glimpse the closeness of Richardson's relationships with senior Tibetan figures, connections which gave him exceptional access to facets of Tibetan religion that were usually off-limits to foreigners. For example, his friendship with Lobsang Namgyal, the Nechung Oracle, meant that Richardson was granted the unique opportunity to photograph the state oracle of Tibet as he went into trance and predicted the future fortunes of Tibet (illus. 57).[33]

By some accounts those fortunes were heavily inflected by the relationship with the British Empire, to the extent that when India gained its independence in 1947 and the British left the subcontinent, it has been argued that the door was left open for China to assume control of the country. As the last representative of the British government (and briefly for that of independent India),

58 Frederick Spencer Chapman, the wife of the *dzongpon* (administrator) of Gyantse, 1936, Dufaycolor transparency.

Richardson was among those who lamented the situation and feared for what might happen next. Therefore, in concluding this discussion of British photography in Tibet, we should note that the photographs accumulated in the period before 1950 when Chinese Maoists began to encroach upon Tibetan territory in earnest, are hugely important. Archived in the United Kingdom, they constitute the most extensive visual record of Tibet under the rule of the Dalai Lamas in existence in any nation, a fact that was acknowledged by the 14th Dalai Lama when he wrote in the preface to a book on British photographs of his country that they gave 'detailed insights into our history and a sense of a culture which has survived since ancient times'.[34] Tragic though it may be, pictures created by the likes of Bell, Richardson and other British colonial agents before 1950 provide rare documentation of a Tibet under Tibetan governance and organized according to Tibetan religious principles. They are therefore greatly valued in Tibetan and Tibetophile circles around the world, if steeped in nostalgia for a place that has been radically transformed since then. Thus, in the case of Tibet photography (unlike that of India or Africa in the postcolonial era, for example), the imperial archive has a particular kind of afterlife in which critique of the contexts of its production has often been muted in deference to the politics of the present.

The Cartography of Photography

If British collections of photographs from Tibet are greater, both in number and duration of coverage, than those of most other countries, this is in large part due to the colonial presence in India. In the late nineteenth century and especially after the Younghusband expedition, British imperial dominion in the subcontinent meant that Great Britain had the greatest proximity and (potentially) the easiest point of access to Tibet when compared with other European colonizing nations. From 1904 until 1947 'frontier cadres' controlled entry to Tibet via its southerly border and repeatedly turned back travellers who were not British or did not meet with their approval. This entanglement between politics and geography suggests that the British photographic record is markedly circumscribed by the physical features of Tibet, as well as by fluctuations in the state of Anglo-Tibetan relations. These factors literally

determined the viewpoint that photographers could adopt in the past, and moreover continues to shape what we might call the 'cartography of photography' in archives today. Once they could assail the Himalayas from their base in India, the British would focus photographically and politically on southern and central Tibet. Therefore, if we were to construct a map using the entire corpus of existing British photographs, it would begin in the Himalayan foothills at Kalimpong or Darjeeling, pass through the valleys of Sikkim, over the high passes on the Tibetan frontier and along the plains of southern Tibet to terminate in Lhasa and its surrounds. Such a map would actually re-inscribe the ancient trade routes between India and Tibet and encompass the historic and political heartlands known to Tibetans as U-Tsang (south and central Tibet).[35]

Although I do not want to pursue a heavily Saidian analysis and claim that the accumulation of visual knowledge about Tibet was rigidly determined by ideological and national imperatives that varied from country to country, I do want to point out that the pragmatics and logistics of geopolitics have had a substantial bearing upon it. To put it simply, between 1890 and 1950 U-Tsang was heavily documented by the British, while the eastern regions of Kham and Amdo were neither as frequently nor as extensively photographed, and when they were, it was not British citizens who were behind the lens. The uncommon opportunity to work in those areas was mainly taken up by individuals from the United States, such as the plant hunter Joseph Rock; the naturalist Brooke Dolan; the 'Tibet envoy' of President Roosevelt, Ilya Tolstoy; the father and son journalistic duo Lowell Thomas (senior and junior); and the missionary Albert Shelton.[36] Most of these people set off on scientific expeditions to Tibet by crossing the Pacific and arriving on the eastern coast of China, before heading out to collect specimens of flora and fauna or to gather 'intelligence' of various sorts, while Shelton, as a Christian missionary, sought to harvest the souls of Tibetan men, women and children. Whatever the nature of their objectives, each of these figures amassed hundreds of photographs.

From the late nineteenth century onwards, several of the major Christian missionary organizations of Europe and North America had set their sights on China and battled to establish themselves there.[37] For those who sailed from North America and ventured inland from China's coastal ports, the

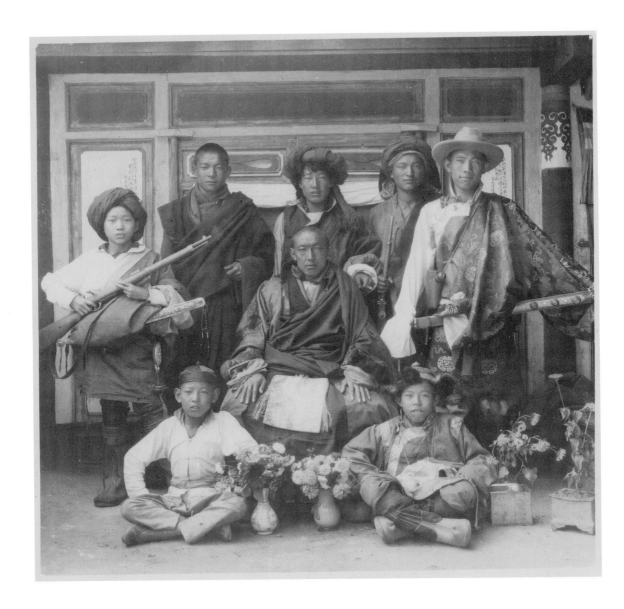

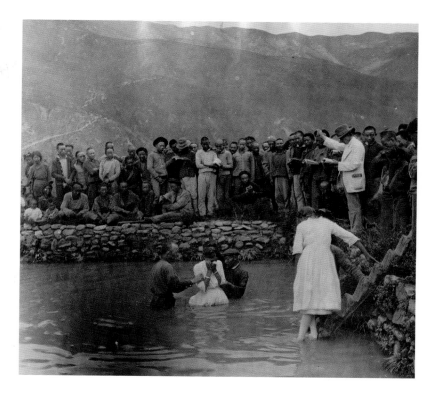

60 Albert Shelton, a baptism in Batang, between 1905 and 1920, gelatin silver print.

orientation towards Tibet was therefore from the east and into the mixed Sino-Tibetan communities of Kham and Amdo, rather than from the south where the British accessed Tibet. When Albert Shelton embarked for China from San Francisco in September 1903, he had only recently been ordained as a Protestant minister and selected to work on behalf of the Foreign Christian Missionary Society due to his skills in medicine and willingness to travel to a place his contemporaries considered particularly demanding and dangerous. Shelton summarized the challenge when he wrote:

> Tibet is the last hermit nation on earth. It is sometimes called the roof of the world, the football of the nations, the keystone of Asia, the home of the pope of Buddhism. Nobody wants it, yet nobody wants anyone else to have it. There it lies, the last stronghold of Satan, where paganism is making its last stand against the onward march of the gospel.[38]

59 Albert Shelton, 'High Lama of Litang monastery with attendants, eastern Tibet', between 1905 and 1920, gelatin silver print.

The trenchant tone of these comments reflects the fact that they were made during a fundraising speech that Shelton gave in the United States in 1910, while on leave from the mission field. By then he had accrued seven years of experience living among Tibetans at Kangding and Batang in Kham. His training as a doctor had proved useful, since he was regularly called upon to tend to the wounded when long-standing feuds between the Chinese and Tibetan residents in the area escalated into combat. Shelton's medical assistance clearly earned him the respect and gratitude of several leading members of the Tibetan community and some of them were therefore willing to be photographed (illus. 59). However, it seems he had little success in converting Tibetan Buddhists to Christianity, since the majority of those he baptized during his tenure in the 'stronghold of Satan' were actually Chinese and often children who had been orphaned as a result of the inter-ethnic violence in the locality (illus. 60). Undeterred, Shelton persisted in his

61 Albert Shelton, yak caravan outside a house in Kham (probably in Batang), between 1905 and 1920, gelatin silver print.

mission, serving for more than thirteen years in Kham until he finally paid the highest price for his devotion. In 1922 he was shot and killed by unknown assailants just outside of Batang. This gruesome end to the career of a missionary who had survived for decades in the 'badlands' of Tibet made headline news across the United States. The *Illustrated London News* also ran lengthy features about Shelton's life and death that were embellished with photographs he had taken in Tibet.

Those photographs undoubtedly proved invaluable to those who sought to eulogize Shelton posthumously, but during his lifetime he had published very few of them. At first, photography was just a hobby he took up to occupy the long, empty hours that could not be filled by his missionary duties on the Tibetan plateau. It later became a more concerted activity since, according to his biographer, Shelton increasingly considered himself to be engaging in 'ethnological' research.[39] As with the British colonial officers of the same period, Shelton started to use the camera to document the lives of the Tibetans who surrounded him and he joined several learned societies, including the Royal Geographical Society in London, where he introduced himself as simply a 'missionary and traveller'. It was only during another break from Tibet in 1921 that he was able to author an explicitly 'ethnographic' article entitled 'Life Among the People of Eastern Tibet', for *National Geographic*.[40] The photographs Shelton presented within it – selected from among the hundreds he had taken – covered topics ranging from house construction to yak husbandry. These images were evidently part of the essay's appeal for the editors of the journal, as Shelton was well remunerated for their use. He later sold the bulk of his Tibet negatives to the Newark Museum in New Jersey for the not insignificant sum of $91.[41] Photography thus aided Shelton in supporting his family of four while living in Tibet on a very modest salary. In addition, it seems that he soon learned to appreciate the value of photographs as exchange objects for facilitating good relations with Tibetans. His memoir, *Pioneering in Tibet*, recounts an occasion when the governor of Lower Kham presented him with an over-abundance of gifts. This put Shelton in a decidedly 'embarrassing position', as a missionary's pay was not on a scale that would allow him 'to give presents in such profusion' in return.[42] His solution was to offer to take portraits of the governor, his wife and his staff (including a bagpipe player) and to furnish them with a set of

copies by way of reciprocation. Such an incident demonstrates that by the 1920s, photographic prints had already become a valuable commodity both for Tibetans and for their foreign visitors.

It seems likely that Shelton also employed photography to enhance his fundraising lectures when back at home in the United States. After 1920, when he had survived two months of imprisonment by Tibetan brigands, he became a particularly highly sought-after public speaker, and one of his anecdotes was so popular that (by his own account) he frequently repeated it. The story told of a journey he had undertaken into the wilderness to the northwest of Batang with a Tibetan acquaintance. Both men were heavily armed but the Buddhist was also equipped with an amulet box (*gau*) that he wore for protection. Because he perceived such objects to be mere superstitious charms, Shelton challenged the Tibetan to a test. He proposed that the *gau* should be hung around the neck of a goat. If, when he fired at it, the goat did not die, Shelton would present the Buddhist with his own rifle as a reward. The challenge was accepted and Shelton described the outcome in his memoir: 'I had smashed the charm box as well as killed the goat.' His companion then 'sat fingering over the different pills, pieces of cloth, etc. that had been contained in the charm box, the very picture of despair'.[43] This cruel demonstration of the

ineffectiveness of a Buddhist amulet no doubt appealed to Shelton's Christian audiences and allowed him to present Tibetans as pathetically credulous. Such an approach was not unlike that of British figures such as Laurence Waddell, Francis Younghusband and Lord Curzon in an earlier era. But if Tibetan Buddhism was often mocked and derided by missionaries and colonial officers in the late nineteenth and early twentieth century, others who visited Tibet in the 1920s and '30s would seek to promote a more positive appraisal of the country and its religion through the services of their cameras.

Picturing Shangri-La

Despite the fact that an American had lived among Tibetans for more than a decade and British troops had marched en masse to Lhasa in 1904, in the 1920s Tibet effectively remained a closed land with a capital that was routinely 'forbidden' to foreigners. Lured by the air of secrecy and mystery that therefore still surrounded it, a number of maverick individuals decided to enter Tibet and make their names in the endeavour. Given the reluctance of both Tibetan and British authorities to allow such exploits, the interlopers often resorted to disguise and deception to enter the country. In his 'amazing odyssey of 1923' – as the *New York Times* reported it – the American William McGovern dyed his skin brown with walnut juice in order to pass as a 'native coolie' during his illicit foray into Tibet.[44] Similarly, in 1924 the French explorer Alexandra David-Néel donned the garb of a Buddhist pilgrim for a journey in which she claimed to have attained the prize of visiting Lhasa. Published in 1927, *Voyage d'une parisienne à Lhassa* was the first of many books that would make her famous as an interpreter of Tibetan Buddhism for audiences in the West.[45] With their occultist leanings and emphasis on the most esoteric features of Tibetan tantric practice, the veracity of David-Néel's writings on Tibet have sometimes been called into question.[46] Her experiments with photography also pose some conundrums. For instance, the image she published in *Voyage* to demonstrate that she had reached the Tibetan capital apparently shows Alexandra and two Tibetan companions in front of the Potala palace (illus. 63). According to its caption, the white face of David-Néel has been covered by a thick layer of lac, a resin used by Tibetan

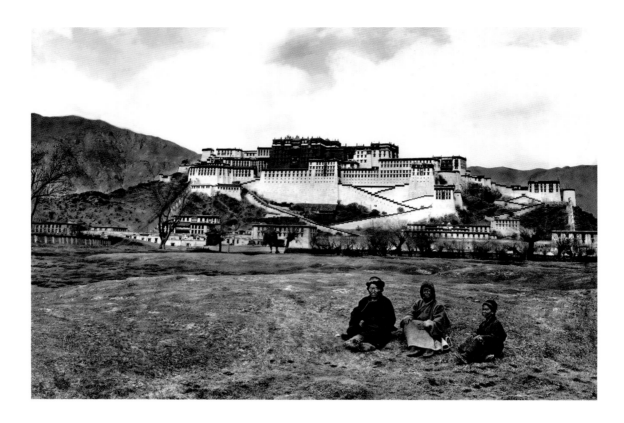

women to protect their skin from the sun. Such an explanation was needed because otherwise it is hard to determine whether it is truly a Western woman sitting at the foot of the Dalai Lama's palace. Her face and body have been so Tibetanized that she is virtually unrecognizable. Even if this picture is genuine, the majority of the images in David-Néel's publications are derived from her travels in other regions where Tibetan Buddhism was practised, particularly in Sikkim, Nepal and British India. Thus, once again, Tibet was being visually reproduced elsewhere.

This is even more emphatically the case in the publicity that announced McGovern's adventures. In its eight-week coverage of his 'life threatening' travels with 'four barbaric servants – one named Satan' in 1924, the *New York Times* reproduced pictures that had ostensibly been taken by McGovern in Tibet. They included a shot of nine masked dancers, described as the 'devil dancers who appeared in honor of Dr McGovern at Lhasa', but in reality the print was produced by the Burlington Smith studio in Darjeeling. Likewise,

63 Collection of Alexandra David-Néel, Madame David-Néel (centre) and two Tibetan companions outside the Potala palace, Lhasa, 1924, gelatin silver print.

the portrait of the 'the undying god of Tibet', which almost filled a page in the newspaper, was not taken in Tibet but in British India during the 13th Dalai Lama's exile there in 1910.[47] India, as previously discussed, was the prime location where photographers and publishers could fill the void created by the absence of photographs taken in Tibet itself. That problem would have a major bearing on the actions and ambitions of the next generation of aspiring photographers of Tibet.

Concerns about the veracity of newspaper and book illustrations may not have troubled their editors and viewers at the time, since making the thrill of the story visually manifest was paramount. But for those who departed for Tibet in the 1930s, every effort would be made to guarantee that they would return home with thousands of photographs of unquestionable authenticity. A few would even insist that they, the pioneering photographer, would appear within them in order to certify their truthfulness and accentuate their heroism. For some such people, a self-portrait taken in the clear light of day alongside a member of the Lhasa aristocracy or standing at the entrance to a major Tibetan monastery would act as proof of their arrival in a country famed for its resistance to outsiders and their cameras. For others, such as the American Charles Suydam Cutting, however, it was sufficient to stay behind the lens and let his pictures do the work. Cutting freely admitted that his tours in Tibet were inspired by the accounts of his predecessors, though in the

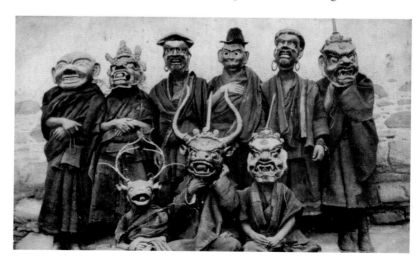

64 John Burlington Smith, Tibetan 'devil dancers', Darjeeling, between 1910 and 1920, collotype postcard. One of the pictures reproduced in the *New York Times'* sensational coverage of William McGovern's journey to Tibet.

aftermath of the sensational McGovern story he allowed for the possibility of fabrication when he wrote: 'Only a handful of white people have ever travelled in Tibet. The tales of the successful, singularly accurate when one considers the opportunity to perpetrate romance and humbug, have incited other hardy spirits in the venture.'[48]

Cutting was a wealthy New Yorker who could afford to spend much of his time pursuing what he called 'creative travel'. His connections in the upper echelons of American society had already enabled him to take part in several major expeditions in Asia, including two in the company of the sons of President Roosevelt. His first venture into Tibetan-speaking territory was in 1928, when he accompanied Kermit and Theodore Roosevelt Jr to collect

65 Charles Suydam Cutting, 'The western gateway to Lhasa', Lhasa, 1935 or 1937, gelatin silver print.

66 Charles Suydam Cutting, 'Monks crowd into the courtyard of the Tashilhunpo monastery', Shigatse, 1935 or 1937, gelatin silver print.

67 Charles Suydam Cutting, 'Monks' boots left outside a ceremonial tent', Lhasa, 1937, gelatin silver print.

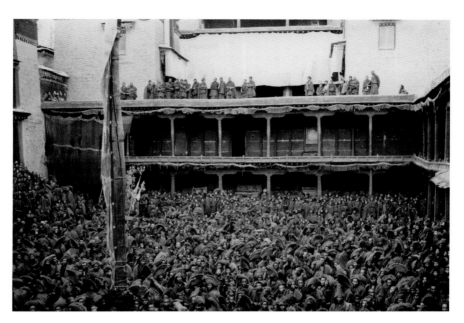

natural history specimens in Sichuan (or Kham) for the Field Museum in Chicago. By 1947 Cutting had visited Tibet three times and could publish a chapter about it in his chronicle of world travel, *The Fire Ox and Other Years*.[49] Overall its pages present the country in glowing terms and the photographic illustrations evoke an appreciation of its landscapes and religion in a way that had eluded his fellow American Albert Shelton.[50] Unpublished prints, now archived at the Newark Museum, also indicate an ethnographic inclination in Cutting's choice of subject matter and compositions. In one, he focuses on a pile of boots left by young monks from the Potala at the entrance to their 'holiday' tent on the outskirts of Lhasa while they picnicked, played games and intermittently learned about Buddhism from their elders (illus. 67). This is an unusual example in which the foreign photographer has focused on the prosaic details of daily life – in this case, monastic footwear – rather than on the monks themselves. Such images failed to enter the public domain however, perhaps because they did not fall into the well-established landscape and 'ethnic type' categories that were so favoured by publishers and readers. A perennial preference for these genres has meant that photography of Tibet and its people could be said to suffer from what the anthropologist Deborah Poole has called the 'aesthetics of same', in which certain topics and visual configurations are constantly repeated over time.[51]

It seems that Cutting's positive appraisal of Tibet and its religion was influenced by the fact that he and his hosts were of a similar high social standing. As a rich American who was able to visit Tibet in the 1930s, his primary contacts were with members of the Tibetan elite, including the 13th Dalai Lama, with whom he had been communicating from America since 1931. The Tibetan leader had apparently asked Cutting to perform 'missions for him in the United States' and to assist in exercising his country's 'true right to sovereignty'. While Cutting could not possibly resolve such a substantial diplomatic conundrum, he did forge a reputation for himself in Lhasa by sending a constant stream of gifts to the Dalai Lama which included a gold watch, books on American architecture, a signed photograph of President Hoover and a cocktail shaker that he thought might be repurposed to churn that staple of the Tibetan diet, butter tea.[52] However, his relations with Tibetans at the lower end of the social spectrum were somewhat less cordial, particularly when he attempted to use his camera. Cutting

complained that 'the natives interfered with the photography, old and young thrusting their faces into the finder, and making it necessary to wipe it off time after time.' Although he also adds: 'Their tiresome behaviour was mitigated by their amiable curiosity.'[53] Unsurprisingly, his book failed to include any portraits of such lowly individuals, and it thereby contributed to a depiction of Tibet that prevailed for much of the twentieth century – one in which the higher forms and high-placed dignitaries of Tibetan religion predominated.

Towards the end of Cutting's final stay in Tibet in 1937, another American arrived in Lhasa by the name of Theos Bernard. He, too, was a man of some wealth with links to the upper classes on the east and west coasts of the United States. In 1910 his uncle Pierre Bernard had founded the New York Sanskrit College and led yoga classes there under the (frankly hilarious) pseudonym 'Oom the Omnipotent'. This family background provided the impetus for Theos first to enrol in a course on Asian religions at Columbia University and then to head towards India and Tibet in 1936 in order to study Hinduism and Buddhism from direct personal experience rather than ancient texts.

At this time a major change was under way on either side of the Atlantic, both in the representation of Tibet and public interest in it. In 1933 the English author James Hilton had published *Lost Horizon*, a novel in which the author invented a utopia, located somewhere in the high plateau of Central Asia, called Shangri-La.[54] The drama of this tale, in which a plane carrying a British officer called Conway crash-lands in a remote part of Asia where time stands still, soon made it an international best-seller. By creating a fictional place whose inhabitants devoted themselves to peaceful contemplation, and where violence was unknown, Hilton struck a nerve with readers who had survived one world war and feared another. In order to craft this vision of a distant paradise Hilton is said to have been inspired by the idea of 'forbidden' Tibet and by Buddhist and Hindu manuals concerning reincarnation and the notion of 'pure lands'. Its has even been suggested that the name he coined for his idyll, Shangri-La, was derived from *shambhala*, the Sanskrit term for a sanctuary where the survivors of a cataclysmic war would be rewarded with enlightenment and immortality.[55] Hilton's book, as well as Frank Capra's 1937 film based on it, undoubtedly promoted Occidental interest in one of the

68 Poster created to advertise
Frank Capra's film *Lost Horizon*
(1937).

most inaccessible regions of Asia, and led audiences to wonder what sorts of
extraordinary people and practices might still exist in that area of the world.

Theos Bernard resolved to make it his personal mission to answer
those questions and to fill what he perceived to be a gaping void in Western
knowledge about Tibetan Buddhism. Often either deriding the erudition of
others or simply ignoring it altogether, Bernard travelled to Tibet in 1936 with
the intention of single-handedly revealing Tibet's secrets, both textually and
photographically. This he evidently believed he had done with the publication
in 1939 of *Penthouse of the Gods: A Pilgrimage into the Heart of Tibet and the
Sacred City of Lhasa*, a book that is packed with extravagant assertions.[56]
In it, Bernard claims that he was initiated into the Geluk school of Tibetan
Buddhism by one of its most senior exponents (the Tri Rinpoche, the most

distinguished non-reincarnate in the Tibetan monastic hierarchy) and he had thereby become the very first 'White Lama'. He also declares that while in Lhasa he was identified as a reincarnation of Padmasambhava, the great Indian teacher and translator who forged the transmission of Buddhism into Tibet in the eighth century. Bernard had apparently been selected by the Tibetans to act as their emissary with special responsibility for disseminating knowledge of Tibetan Buddhism to the unenlightened Occident.

Since pronouncements of this sort and further dubious aspects of Bernard's narrative have been critiqued by others, his photography might similarly be called into question.[57] A full analysis is impossible here but, to put it rather bluntly, Bernard's deployment of photography constitutes the most protracted exercise in self-promotion in the many twentieth-century publications on Tibet that I have studied. It is clear from the preparations he made before setting off for the country that Bernard was acutely conscious of the importance of images in documenting his quest. He spent over $1,000 on cine footage – for almost 2 kilometres (6,000 ft) of stock – and he acquired two high-quality still cameras so that one could be constantly loaded with black-and-white film and the other with colour. References to the 'orgy of photography' (Bernard's phrase) that he was then able to indulge in litter the pages of *Penthouse of the Gods.*

Bernard was also determined to get excellent results. While still in Tibet he sent negatives and film rolls to Calcutta and pestered the manager of the Kodak studio in that city for news of their quality once processed. The manager obligingly put the American's mind at rest by writing: 'I'm sure you'll feel good . . . you have the finest pictorial record in existence.'[58] The letters Bernard sent home to his wife also record his competitiveness in relation to the work of other photographers and how he frequently contrasted his efforts (favourably, of course) with those of his fellow American, Cutting, and the Englishman Frederick Spencer Chapman, who had been in Lhasa a little earlier. In fact Bernard denounced the British photographic project in Tibet in its entirety, stating that it merely reproduced exteriors. From his point of view, not only had British photographers failed to get beyond the facades of Tibetan buildings but they had failed to capture the 'inner soul of the Tibetan'.[59] He, on the other hand, had penetrated both the jealously guarded sanctums of Tibetan religious institutions and the minds of their occupants.

On arriving in London in 1937 to publicize his five-month adventure in Tibet, Bernard penned a catalogue of his achievements for the *Daily Mail* newspaper. Point five on that list proclaimed that he had 'photographed secret temples which natives themselves have never entered'.[60] However, he failed to mention that for a non-Tibetan such feats were usually only possible through inducements or influence. A close reading of *Penthouse of the Gods* throws up some clues as to Bernard's tactics in this respect. For instance, it becomes apparent that an illustration showing the author admiring an array of glittering butter lamps in the monastery at Gyantse was only arranged after he had donated the butter as an offering (illus. 69). On other occasions Bernard quite simply presented money to monastic officials in order to be able to use his cameras, as the author of a confidential report compiled in 1940 confirms. Following the publication of his memoir in 1939, some of the overblown pronouncements within it were called into question by leading British 'frontier cadres'. They selected Rai Bahadur Norbu Dhondup, a Tibetan with a long career of service to the British who had observed Bernard's behaviour in Tibet at first hand, to comment. His response was detailed and damning:

> His [Bernard's] modus operandi was to prepare the day with a handsome cash gift and advise the monastery officials when they may expect him. At the appointed time, he would arrive complete with Tharchin and the cameras and would be received with pleasure by the monks . . . whereupon Tharchin would reel off as many film [sic] as possible from many angles. Normally the monks object to indiscriminate photography but Bernard's clever generosity would, as he knew, over-ride such scruples temporarily and in many instances permission was readily given to photograph what he liked.[61]

In addition to exposing just how Bernard had accessed Tibet's 'secrets', this extract also highlights the importance of a local agent in the production of his photography.

Theos Bernard first encountered Gergan Tharchin in 1935 when he started attending lessons in the Tibetan language at Tharchin's home in Kalimpong, India.[62] The American then invited Tharchin to act as his chief aide during his travels in Tibet the following year. Although later describing him in print as

69 Gergan Tharchin(?), Theos Bernard admiring butter lamps inside the monastery at Gyantse, gelatin silver print, 1939.

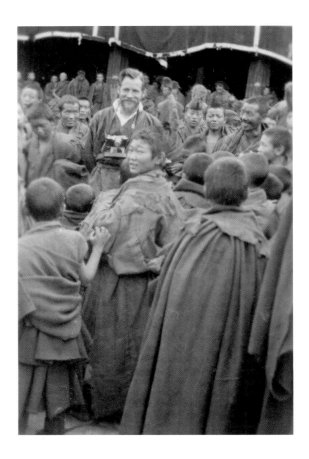

70 Gergan Tharchin(?), Theos
Bernard with monks outside the
main assembly hall at Gyantse,
gelatin silver print, 1939.

'extremely competent' in matters of diplomacy and organization, Bernard
did not acknowledge that he was utterly dependent on this English-speaking
Tibetan for the success of his photographic project. Not only did Tharchin
photograph Tibetans on the American's behalf, but it could surely only
have been he who took the many portraits of Bernard that would feature so
prominently in his book. Both these factors are evident in an illustration from
Penthouse of the Gods where the 'White Lama' is apparently welcomed at the
monastery of Gyantse by a group of cheerful monks. The presence of a fellow
Tibetan behind the camera may well have elicited their positive response.
In fact, Bernard knew very well that some Tibetans seriously objected to the
attentions of foreign photographers, since in a chapter titled 'I Escape with
my Life' he writes that he was stoned by a crowd in Lhasa when he ventured
out alone to take some pictures that simply 'struck' his 'fancy'. Regardless of

such warnings, Bernard still persisted with his photography. Even when the monks of the Potala said that they would rather he did not photograph the tombs of the Dalai Lamas, he continued and merely tried to operate 'unobtrusively' instead. In mitigation, Bernard told his readers that he was given 'special consideration' by the Tibetans because he had 'gone around the world to make this sacred pilgrimage; so they granted me the privilege of making a Memory Album of interiors while the ceremonies were in progress'.[63]

Bernard's 'Memory Album' of photographs would prove crucial to the enhancement of his profile when he returned to the United States, but he would also require a full range of outfits to enable him to play the part of the 'White Lama' in a series of events designed to promote his magnum opus.

71 Theos Bernard, 'Ceremony at the tomb of the late Dalai Lama' in the Potala palace, Lhasa, 1937, gelatin silver print.

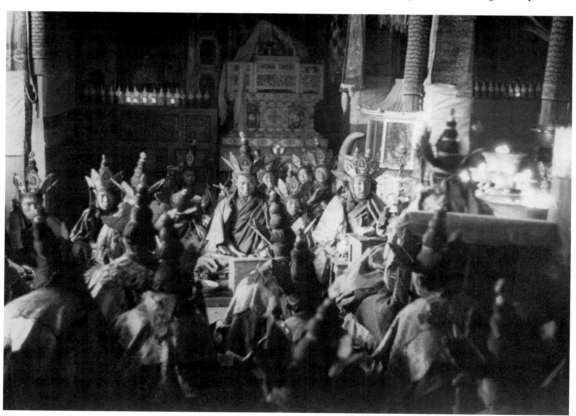

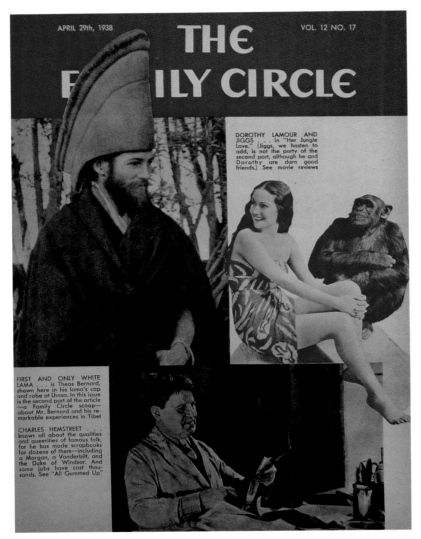

72 The 'White Lama', Theos Bernard, on the cover of *The Family Circle* magazine, April 1938.

Therefore, before he left Lhasa, Bernard purchased fine textiles and had clothing made in various styles, ranging from the robes of a Geluk monk to that of an aristocrat in the Tibetan government. As a result of these careful preparations, the cover of *Family Circle* magazine for April 1938 presents the extraordinary spectacle of a white man in full Tibetan monastic dress

alongside a glamour-shot of a scantily clad Hollywood starlet.[64] Sensational promotional materials of this sort enabled Bernard to broadcast his 'unique' insights into Tibetan Buddhism across the United States. In terms of photography however, it is only his vanity that makes Bernard's presentation of Tibet exceptional. Of the seventy illustrations in *Penthouse of the Gods* almost a quarter feature himself. He is pictured on the road to Lhasa; with the Regent of Tibet; meeting leading figures in Lhasa's elite social circles; in front of Tibet's most sacred temple; inside and outside various monasteries; and iconized as the 'White Lama' in Tibetan robes and headdress for the frontispiece. In the 1940s such pictures propelled Bernard to fame and found a ready market among those captivated by the thought of an American who had been to 'Shangri-La'. He went on lecture tours around the world and taught yoga to admiring acolytes in Manhattan, but it seems Bernard remained unfulfilled. We know, at least, that he viewed the collection of Tibetan books and objects he had acquired in Tibet in 1937 as incomplete, for a decade later he travelled to Spiti in search of more rare manuscripts and artworks. While engaged in a search in the monasteries of the Western Himalayas, he disappeared; at first he was presumed missing, but eventually he was pronounced dead. The body of the 'White Lama' was never found.

Photographic Interactions in Lhasa

If Theos Bernard could be said to have bequeathed some sort of legacy via his photography, it was one that confirmed the mystical tropes of Shangri-La. Such a view presents a romanticized picture of Tibetan Buddhism and defines its homeland as a timeless haven of spirituality. In their texts and illustrations, many accounts of Tibet that were published in the West later in the twentieth century continued to conjure an image of a country whose theocratic form of governance and feudal social structure had preserved it in a state comparable only to that of medieval Europe. From this conservative but admiring perspective, Tibet was perceived to be immune to the supposed civilizing advances that were underway elsewhere in the world, as well as to the pernicious effects of modernity and industrialization. But this characterization overlooks the fact that at the behest of the 13th Dalai Lama in the 1930s, Lhasa had acquired

some street lighting, a postal and telegram service, a fighting force whose uniforms, weapons and methods had been modelled on those of the British army, and at least one radio that received a signal inside the Potala palace. There were even some cars that had been carried over the Himalayas as gifts for the Dalai Lama from his foreign admirers. Irrespective of all this, many visitors continued to repeat the refrain that Tibet would never be modern and that the only wheels they saw there were of the praying, rather than the transportation, variety. In the eyes of such outsiders, Tibet was irredeemably, but attractively, archaic. These critics also ignored the fact that the very 'modern' device used to record their impressions of antiquated Tibet – the camera – had already been embraced by Tibetans.

In 1933, the same year that *Lost Horizon* was published, the 13th Dalai Lama passed away. During the period immediately following his demise, the policy of the Tibetan and British Indian governments towards photography in Tibet appears to have become somewhat freer. At least we can say that between 1936 and 1939 Lhasa hosted an unprecedented number of foreign photographers. In addition to Americans such as Cutting and Bernard, residents of Lhasa witnessed the arrival of German, Italian and British contingents. The latter returned to Tibet in 1936 under the leadership of Basil Gould and with a civilian member of the party who was noted for his skill in photography: Frederick Spencer Chapman. In addition to shooting cine-film that was processed *in situ* and projected before delighted Tibetan audiences in Lhasa, Chapman experimented with the latest Dufaycolor in one of his still cameras. The results would adorn his book *Lhasa: The Holy City*, while his black-and-white work was primarily reserved for the official record of the Gould mission that would be archived in London and Calcutta.[65] In 1937 the Italian scholar Giuseppe Tucci reached Lhasa with the photographer and anthropologist Fosco Maraini to help him document the art and architecture of Tibet. Maraini also went on to publish his most

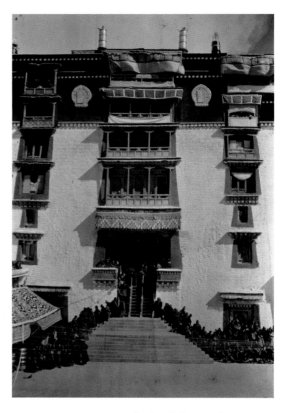

73 Frederick Spencer Chapman, eastern courtyard of the Potala palace during the *Tse Gutor* ceremony marking the end of New Year celebrations, Lhasa, 1937, Dufaycolor transparency.

74 Fosco Maraini, Princess Pema Chöki Namgyal of Sikkim, 1937, gelatin silver print. Published in *Secret Tibet* (1952) with the caption: 'Am I foolish to think that a lama must be handsome to lead the mind to faith?'

attractive images in *Secret Tibet*, a book designed for a wide readership, while Tucci's own photographs were reproduced in academic publications and stored in Rome to ensure that an archive of his groundbreaking art historical research was preserved.[66] In 1938 a German expedition directed by Ernst Schäfer entered Tibet with a team of experts primed to examine the geology, flora, fauna and human occupants of the country. It included the anthropologist Bruno Beger, whose main duty was to collect data on physical variation by recording cranial measurements, eye colour and so on, according to the current criteria of ethnology, and to investigate whether Tibetans might be of 'pure' Aryan extraction. He also helped to amass a very large collection of Tibetan material culture for accession in German museums. Contentious as it remains to this day due to its connections with senior figures in National

75 Ernst Schäfer, Bruno Beger measuring a Tibetan for his anthropological research, Tibet, 1938, film negative.

Socialism, this expedition generated 17,000 photographs of Tibet and must nevertheless be acknowledged as one of the most comprehensive visual projects ever conducted on the Tibetan plateau.[67] It might also be noted that the images created by members of Schäfer's team when they reached Lhasa in 1939 feature Tibetans taking great pleasure at the chance to handle the latest models of German photographic equipment.

Such photographically mediated encounters between foreigners and Tibetans enables us to conclude this brief discussion of the transcultural climate of Lhasa in the 1930s and the nascent modernity it fostered. Among the many pictures taken by members of all the groups mentioned above, it is remarkable that portraits of certain noteworthy figures in Tibetan society recur, including laymen from aristocratic families, senior religious figures, officials from the Potala palace and the Tibetan government, as well as the leading ladies in Lhasa's elite social circles. By far the most frequently occurring, however, are those of two individuals: Reting Rinpoche and Dasang Damdul Tsarong. As the regent of Tibet during the interregnum between the death of the 13th Dalai Lama and the installation in 1940 of his successor,

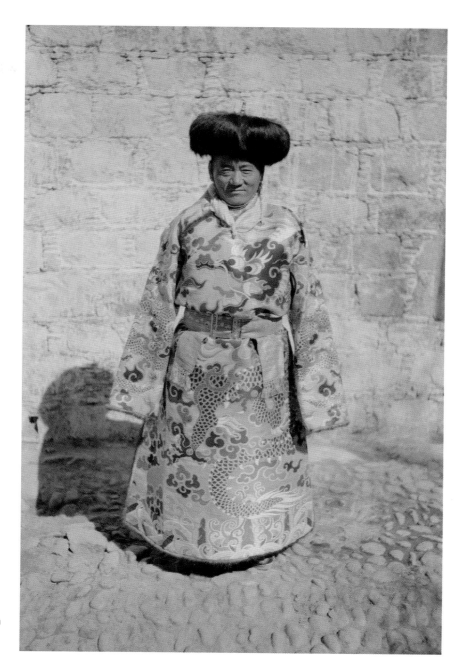

opposite:
77 Frederick Spencer Chapman, Reting Rinpoche with bodyguard in the garden of his summer palace, Lhasa, 1936, gelatin silver print.

right:
78 Frederick Spencer Chapman, Dasang Damdul Tsarong in the fine robes he wore for New Year in Lhasa in 1937, from a Dufaycolor transparency.

Tenzin Gyatso, Reting Rinpoche was the most powerful religious figure in the country. Tsarong, on the other hand, was a layman. Having begun life as a servant at the summer palace of the Dalai Lamas, the Norbulingka, he had made a meteoric ascent of the Tibetan social hierarchy and built up a substantial business empire. By the 1930s he had become one of the richest men in the country and commander of the Tibetan army.[68] Between them, these two men had the authority and resources to facilitate the brief opening of Tibet to outsiders in the late 1930s, and their portraits therefore recur in the collections of European photographers. Not only did Reting and Tsarong entertain foreign visitors, but they also quizzed them about photography, a hobby the pair had already enthusiastically taken up.[69] Tibetan engagements with the camera are discussed at greater length in Chapter Three, but to complete this short survey of outsider's representations of their country in the first half of the twentieth century, let us finally consider a rather unusual example.

An Indian Camerawoman in Tibet

We have heard a good deal about the exploits of men in Tibet in the period between 1900 and 1940, but apart from Alexandra David-Néel, few women have featured in the story so far. Since histories of exploration and photography often fail to mention the contributions of women, it is important not to make the same error here, but it must be said that hardly any foreign females were allowed to travel to Tibet in the early twentieth century. As gatekeepers controlling entry to the country, British frontier cadres once again played a role in this. It is apparent from memos addressed to their superiors that such men generally believed 'the fairer sex' should not be allowed to pass over the Himalayas. However, the wife of Political Officer Leslie Weir did accompany him to Tibet in 1932 as the family believe that it was she who took many of the photographs that now bear his name.[70] Similarly, Cutting's wife is never acknowledged as a photographer of Tibet but she was certainly present on his trip in 1937 as prints in the Newark Museum show her with a camera in hand. No doubt other examples of this sort will come to light if concerted attention is paid to this topic in future.

For now, we will deviate from the inevitably masculine emphasis of this chapter by closing with the work of an exceptional woman.

Li Gotami Govinda was a Parsi from Mumbai whose passion for art took her to the Slade School of Fine Art in London in 1924 and to Rabindranath Tagore's university at Santiniketan in Bengal to study under the leading modernist painter Nandalal Bose in 1934. However, by the late 1930s she had turned her attention to photography and co-founded the Camera Pictorialists of Bombay (now Mumbai).[71] She later 'thanked her lucky stars' for the knowledge she had gained in that association since it proved invaluable when she made her two trips to Tibet in 1947 and 1949.[72] Those opportunities arose due to her marriage to Ernst Lothar Hoffmann, a German who had acquired the name Anagarika Govinda during his conversion to Theravada Buddhism in Sri Lanka in 1928.[73] A few years later he met an eminent Buddhist teacher from Sikkim called Ngawang Kalsang and switched his allegiance to the Tibetan tradition. In brief, this meeting led to Anagarika and his wife adopting Tibetan Buddhism as their religion, which inspired the couple to travel to its source in Tibet. They began their journey of 1947 from India with a visit to the monastery of Ajo Repa Rinpoche on the southern fringes of Tibetan territory. Impressed by this wise old adept, the two switched their affiliation yet again – this time to the Kagyu school of Tibetan Buddhism, rather than the Geluk. Gotami Govinda took several portraits of their revered teacher and continued to photograph Tibetans of many backgrounds during the course of her travels in Tibet, but her preference was undoubtedly for portraits of monks and reincarnates (illus. 80). In this she veered towards a Shangri-Laist approach, since she considered these individuals to be special beings endowed with outstanding 'spiritual' skills. Nonetheless, it is her photographs of the buildings they occupied and the artworks that surrounded them that are perhaps the most remarkable.

As an artist by training, Gotami Govinda was attracted to the paintings and sculptures that adorned Tibetan monasteries, and as she viewed them she experienced 'a realization of the strength and beauty of these ageless masterpieces'.[74] Despite the fact that she was reduced to using a small, folding Kodak camera (when her more expensive reflex failed to function at altitude), she managed to produce an impressive record of subjects that had often been ignored by her male predecessors. In the gloom of the multi-chambered

79 Li Gotami Govinda, the massive figure of Ratnasambhava inside the Kumbum stupa at Gyantse, 1947 or 1949, film negative.

80 Li Gotami Govinda, Ajo Rinpoche in the shrine room of his monastery in southern Tibet, 1947, film negative.

Kumbum stupa at Gyantse, for example, she succeeded in encompassing the two-storey-high statue of Ratnasambhava in her viewfinder and discovered that the play of narrow beams of natural light on its surface could be used to great effect. The same approach was applied when the Govindas reached Tsaparang in western Tibet and set about documenting the wall paintings and sculpture that had survived from the era when King Yeshe-Ö had reintroduced Buddhism there in the tenth century. Apart from Tucci's partial photographic documentation of the site in the 1930s, no one had fully focused on the splendour of that monastic complex before and very few non-Tibetans had traversed the dramatic landscape that surrounded it. When Gotami Govinda's photographs of its elegantly sculpted Buddhas and bodhisattvas were eventually published in *Tibet in Pictures* in 1979, her husband explained why he thought they were important:

> they make a particularly valuable contribution to our knowledge and remembrance of Tibet. They not only show the country and its people as they were before the Chinese invasion, but they show a number of Tibet's great works of art that have been unknown to the West.[75]

81 Li Gotami Govinda, 'Descent into the Canyon', a view of the Tsaparang valley, 1949, film negative.

82 Li Gotami Govinda, the monastery of Tholing, 1949, film negative.

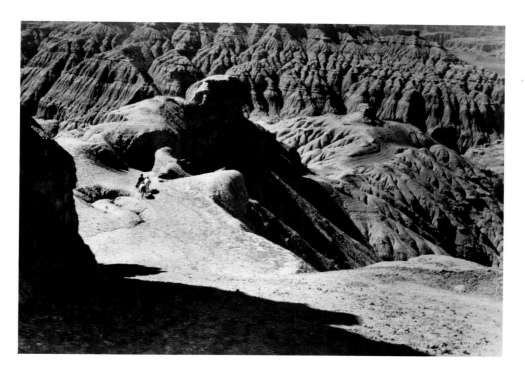

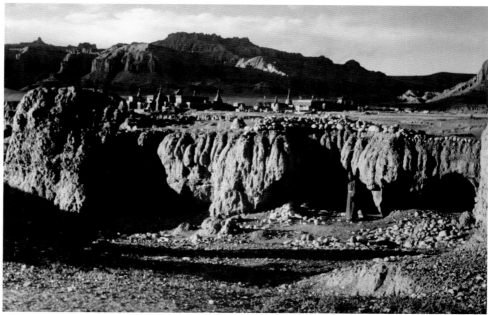

Sadly, a comparison with photographs taken inside the monasteries at Tsaparang and Tholing more recently exposes a stark contrast between the riches Tibet once had and what it has since lost.

Anagarika Govinda's reference to the 'Chinese invasion' brings us to a rather pessimistic conclusion of this discussion. If, in the decades after 1904, Western photographers promoted a romantic vision of Tibet as Shangri-La, after 1950 the geographical axis switched to the opposite direction when control of the visual representation of the country fell into the hands of individuals from its neighbour in the east: China. Once Tibet came fully into the orbit of Chinese Communism, and especially during the Cultural Revolution of 1966–76, Han Chinese photographers concentrated on depicting it as a Maoist utopia rather than a Buddhist one. Meanwhile, the 14th Dalai Lama and thousands of his followers fled their homeland and sought exile in India and Nepal. Their departure after 1959, and the creation of a wider Tibetan diaspora over the following decades, has meant that, for many non-Tibetans today, the primary point of access to Tibetan religion and culture is no longer to be found in Tibet proper but is embodied in the globally dispersed community of Tibetans and, above all, in their leader, the 14th Dalai Lama.

Tibetan Encounters with the Camera

Ever since his escape from Tibet in 1959, Tenzin Gyatso, the 14th incarnation of the Dalai Lama, has been constantly photographed. From his first appearance on the cover of *Time* magazine in April of that year, his popularity among press photographers has matched that of Hollywood stars and the heads of major nations, though he, of course, is stateless (illus. 83). As the world's most famous refugee, the leader of all Tibetan Buddhists, and roving ambassador for the Tibetan cause, Tenzin Gyatso's existence since leaving Lhasa has been one of incessant movement conducted under the gaze of innumerable audiences and cameras. His life has therefore been more visible and more thoroughly documented visually than that of any previous Dalai Lama.

For centuries, Tenzin Gyatso's predecessors had been portrayed in the generic style of Tibetan religious paintings, in which the delineation of an individual's countenance was not the highest priority. For the foreign photographers who met him in India shortly after he had survived the rigours of crossing the Himalayas in 1959, however, it was precisely those physical markers of a distinct personality that caught their attention. Gyatso's studious appearance, in thick-rimmed glasses and plain maroon robes, signified the virtues of Buddhism and the understated heroism of a young man who had been forced to flee his country following an uprising by residents of Lhasa against the Chinese. After a century of outsiders' attempts to enter his homeland and photograph it, the Dalai Lama's departure suddenly brought Tibet directly to them, in the form of a modest monk who could represent the narrative of all Tibetan exiles and the place they had left behind.

In fact, the year 1959 was not the first time that Tenzin Gyatso had been photographed; nor was it the first time that mass reproduction of his image

TWENTY-FIVE CENTS

APRIL 20, 1959

THE ESCAPE THAT ROCKED THE REDS

TIME

THE WEEKLY NEWSMAGAZINE

THE
DALAI LAMA

$7.00 A YEAR

VOL. LXXIII NO. 16

84 Archibald Steele, Tenzin Gyatso shortly after his identification as the 14th Dalai Lama, in Amdo, 1939, gelatin silver print.

83 The 14th Dalai Lama on the cover of *Time* magazine in April 1959.

had been used to cultivate an aura of sanctity and charisma surrounding him. At only four years old, in 1939, he was pictured by Archibald Steele, the China correspondent of the *Chicago Daily News*, at Kumbum monastery in Amdo. Six years after the death of the 13th Dalai Lama, the boy had been identified as the next incarnation of Tibet's spiritual leader.[1] Though Steele's image of a small child on the verge of assuming weighty responsibilities was primarily used for journalistic purposes outside Tibet, within the country the moment of the creation of that portrait marks the beginning of Tenzin Gyatso's transformation from a mere mortal into the manifestation of the bodhisattva of compassion (Chenrezig) and the reincarnation of Tibetan Buddhism's most important spiritual teacher (a *tulku*). It also alludes to the conversion of a photographic print into an object of Buddhist veneration, as tiny copies of the Dalai Lama's image went into circulation within the country. They would assume the role of *rten*, or a support to religious practice, just as books, statues and paintings had revealed the speech, body and mind of the Buddha to his followers since his death. Thereafter photographs of the 14th Dalai Lama have been considered to have religious efficacy for Tibetan Buddhists.

However, photographic representations of the 14th Dalai Lama do not simply operate in that mode today and nor did they in the past. As he reached his maturity in Tibet, Tenzin Gyatso was also pictured in more secular and political contexts. This points to the dual nature of his role – as a religious leader and a diplomat – as well as to the development of photography in Tibet and its reception by internal and external consumers. It also reprises a question raised earlier in this book: could Tibetans gain some control of the camera and the representation of their country? It has been established that the photographing of Tibet, as well as its Himalayan proxies, was largely

dominated, from the mid-nineteenth century onwards, by outsiders to the country. This chapter offers a corrective to that account by considering the extent to which Tibetans themselves have been able to engage with the technology, either as subjects of it, or as agents in its manipulation. We begin with the 14th Dalai Lama himself.

The Austrian mountaineer Heinrich Harrer's account of the seven years he spent in Lhasa in the 1940s records that the young Tenzin Gyatso was fascinated by all types of cameras and could assemble and operate a cine-camera with some skill.[2] Decades later, when I asked the Dalai Lama about his interest in photography, he confirmed that he had learned a great deal from Harrer in Tibet and had continued to enjoy taking photographs in the early years of his exile in India.[3] He also disclosed that he still treasured the Rolleiflex he had acquired in the 1960s, though he regretted that in recent decades there had been little time to pursue his hobby. So, it is clear that Tenzin Gyatso was a keen photographer from childhood. There is also evidence that he understood the power of his image and how it might be interpreted by others. By the time he had assumed the full authority of a Dalai Lama in his teens, Tenzin Gyatso had adopted the form of dress commensurate with that status. When he travelled to Beijing in the mid-1950s for negotiations with Mao Zedong for instance, the visual record of those meetings shows him clad in the richly patterned silk brocade gowns that Tibetan dignitaries had worn since the Qing dynasty. (An outfit that contrasted greatly with the utilitarian cotton suit worn by the communist leader of China.) Thus when the Dalai Lama donned the plain robes of an ordinary Tibetan monk at his first encounter with the international press in India in 1959, it marked a significant shift in his self-presentation and that of the religion he would personify for the outside world. Like Mahatma Gandhi – a figure Tenzin Gyatso first admired from a distance in Tibet – who had worn the *dhoti* (loincloth) strategically within the anti-colonial struggle, the 14th Dalai Lama appears to have appreciated the importance of sartorial matters when making a statement visually.[4] This was an early indication of the principles of 'Buddhist modernism' that he would advocate throughout the following decades in India and for which other Gandhian values and tactics were an inspiration.[5]

Since the 1960s the 14th Dalai Lama has promoted revisions to the traditional practices of both his monastic and lay followers and

85 Unknown press photographer, Mao Zedong with the 14th Dalai Lama (right) and the Panchen Lama (left) in Beijing in 1956.

espoused adaptations of long-established Tibetan Buddhist concepts of anti-materialism, ethical accountability and environmental awareness to suit the new conditions of exile in South Asia and beyond. Within that project, just as his self-presentation before the world's press was altered as much by design as by force of circumstance, so the daily practices of his devotees have been modernized and transformed under his leadership. By describing and presenting himself visually as 'just a simple monk', the 14th

Dalai Lama has enhanced his reputation as a figure of high spiritual and moral authority and has chosen to articulate it through a photo-icon that can be distributed globally. His image carries an especially heavy burden of representation in disseminating the story of Tibet after 1959 to all corners of the planet and in counteracting the fact that its possession and display is banned in the People's Republic of China.[6]

The Photograph Reincarnate

The adoption of photography as a suitable medium for the depiction of high-ranking Tibetan religious figures may appear to be a radical departure from its historic antecedents. Whether in the Shangri-La vision of Tibet as a domain of pure spirituality, untainted by industrialization, or from the Maoist point of view in which devotion to Buddhism is deemed to have created a benighted state of backwardness, Tibetans have frequently been characterized as allergic to technological change. However, as the Tibetan writer Jamyang Norbu has asserted in his refutation of such pronouncements, 'among the innovations of the West, photography seems to have come to Tibet the earliest and was tremendously popular from the start.' In fact, Norbu dates the onset of this zeal to the beginning of the twentieth century, and also makes the important point that the Tibetan neologism for a photograph – *par* – 'does not carry any sense of magic and mystery as might be expected from the language of a primitive people overawed at modern technology'.[7] *Par* simply means print, reproduction or copy. This echoes a fundamental concept in photographic theory in which the camera is, in essence, the producer of indexical referents, or direct copies of nature arising from the impact of light onto papers and chemicals. Roland Barthes took the idea one step further when he wrote:

> The photograph is literally an emanation of the referent. From a real body, which was there, proceed radiations which ultimately touch me, who am here . . . a sort of umbilical cord links the body of the photographed thing to my gaze.[8]

Although Tibetans do not use the same vocabulary, it seems that by embracing the capacity of a photographic print to transmit the aura of a spiritual master, they are crafting a kind of Barthesian 'certificate of presence'.[9]

It could be argued that this procedure is merely a recent adaptation of long-established Tibetan Buddhist tenets governing the production of images of all kinds. According to Tibetan artists' manuals, the earliest depictions of the Buddha were created either by capturing the rays of light emitted by his enlightened body onto a cloth or by copying his reflection as it fell onto the surface of a lake. In both cases we should note that the human eye could not gaze directly upon the living Buddha and his appearance could only be reproduced with an intermediary substance – such as a textile – or via a reflective plane, just as a photograph is essentially an image framed by the photographer's eye and then refracted through a lens onto glass or paper (and later, pixels). Tibetan understandings of the special features of the body of a reincarnate and the sacredness of things that have been touched by it are also pertinent here. In the past, some of the most highly valued Tibetan paintings were those that carried an impression of the hand or footprints of a *tulku*.[10] Such things indicate that the more direct the contact between the object and the referent, the more potent it was thought to be. This arises from the wider context of Tibetan notions of materiality and immanence in which the tangible world is permeated by the energy of unseen powers and absent persons. From items with the greatest sanctity of all – the relics of the actual body of the Buddha, which are worshipped in Tibetan rituals both at close quarters during pilgrimage and from far away – to the printed photograph of a Dalai Lama, all such things can confer blessings and transmit the sacred power of the figure they connote. Thus in Tibetan Buddhist settings, and contra Walter Benjamin's famous pronouncement, the aura of an exceptional person may not 'wither in the age of mechanical reproduction' but can be augmented by its photographic replication and distribution.[11] When treated with due deference within a bodily praxis of proxemics and empowerment, the photographic index of a person, either living or dead, can activate their agency.[12] By placing photographs in special locations (whether in the home or a monastic context) and venerating them, Tibetans animate the aura of their religious leaders.

For these reasons, framed portraits of an absent head monk or 'root guru' (such as the Dalai Lama or the Panchen Lama, the second most senior figure in Tibetan Buddhism) are placed on the thrones they would occupy when visiting a monastery and treated as if they were always potentially present (as in illus. 86). Often a print representing their previous incarnation is also located nearby to indicate the transmission of the lineage and the idea that an individual is merely a temporary receptacle for the transmigration of the soul from one body to another. The subject of a Tibetan Buddhist photograph is therefore construed to live beyond the physical and temporal parameters of the moment at which they were recorded by the camera, and such portraits of reincarnates operate according to different rules from those of lay people. Importantly, they are not to be construed as memento mori, as has often been the case for photographs created in a Judaeo-Christian context. In this respect, Tibetan Buddhist conceptions of photography fly in

86 Clare Harris, photo-icons of the 10th and 11th Panchen Lamas (foreground) and the Dalai Lama (background) in use in a Tibetan monastery in northeast India, 2015, digital photograph.

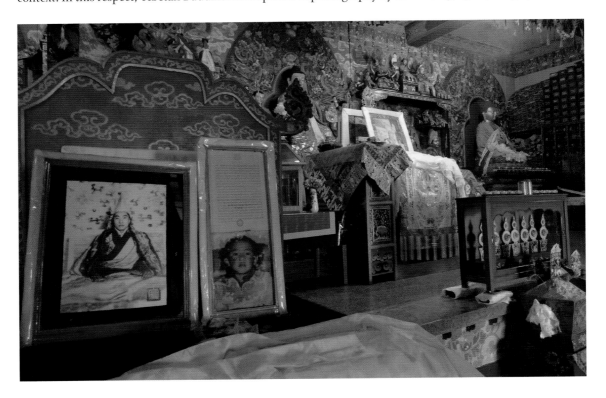

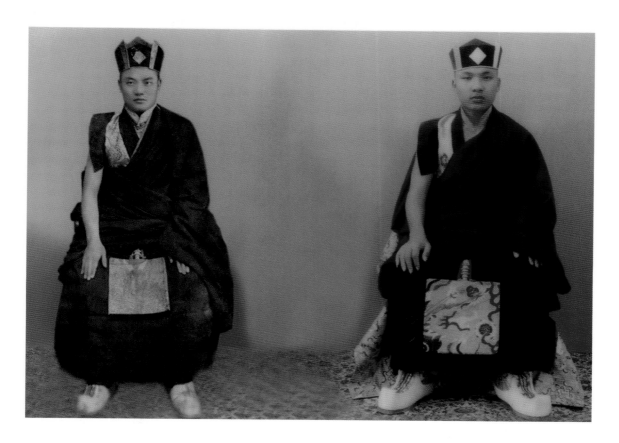

87 Bhutook, two Karmapas (16th incarnation on left and 17th on right), created from a black-and-white portrait by Hugh Richardson and a colour one by Bhutook in McLeod Ganj around 2010, colour print from digitally manipulated files.

the face of Western theorists' preoccupations with memory, mortality and the 'recursive distancing between the indexical representation and the lost living presence that the photograph cannot bridge'.[13] On the contrary, the replicatory qualities of photographic technology have been employed by Tibetan photographers precisely in order to overturn the ruptures created by the passage of time, exile and death, as this fused image of the current and previous incarnations of the Karmapa (head of the Karma Kagyu school of Tibetan Buddhism) created by the refugee photographer Bhutook makes clear. In a system of reincarnation, the photographic copy (*par*) can be transformed into a power object (*rten*) and thereby demonstrate that the transmigration of souls through multiple bodies is potentially endless.[14]

Precursors

Although the 14th Dalai Lama has keenly embraced photography, both as a personal practice and a mode in which to represent his religious and political authority, he was not the first eminent Tibetan monk to do so. In fact the earliest indications of Tibetan enthusiasm for the camera can be dated as far back as 1879 and to the monastery of Tashilhunpo at Shigatse, the seat of the second most important figure in the Tibetan Buddhist hierarchy: the Panchen Lama. At this time, the abbot of Tashilhunpo was known as the Sengchen Lama and, according to Sarat Chandra Das, it was he who facilitated the Bengali spy's clandestine visits to Tibet in 1879 and 1881 and gave him lodging for several weeks at his monastery.[15] During one of their initial conversations, the abbot confessed to a love of photography and revealed that he owned a box of lantern slides with images of a foreign country he could not identify. Das immediately recognized the country depicted in the scenes as France. He also told the monk that he was an experienced photographer himself and that back in Calcutta he had mastered the wet collodion process, which involved applying a fine layer of cellulose nitrate to a glass plate and processing it very quickly. At this news, his host asked Das to do several things for him both in India and Tibet: he should ensure that materials for photography be sent to Tashilhunpo, help create a set of lantern slides of the monastery to entertain the monks and bring a copy of Gaston Tissandier's *A History and Handbook of Photography* (1876) to Tibet so that the two men could translate it into Tibetan. It is not known how many of these requests Das managed to fulfil. Certainly no photographs made in Tibet either by the Sengchen Lama or by Das himself have yet come to light, but this information remains crucial in taking the start date of Tibetan interest in photography back to the late 1870s, rather than the early twentieth century. It is also important to acknowledge the agency of a Buddhist monk who, though physically isolated on the landlocked Tibetan plateau, had already glimpsed the outside world in lantern slide form and earnestly desired to learn more about photography. Finally, this encounter at Tashilhunpo reiterates the general argument about the primacy of British imperial networks in the spread of photographic equipment, skills and knowledge into Tibet.

88 John Burlington Smith, the Panchen (or Tashi) Lama, photographed in Darjeeling, as reproduced in *The Graphic* on 30 December 1905.

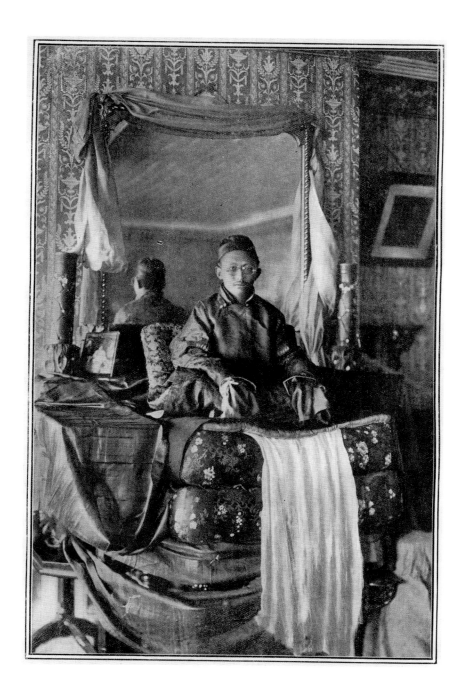

One of the Sengchen Lama's most urgent requirements was to mimetically reproduce views of his surroundings and to make slides that could be projected at the monastery for the viewing pleasure of his colleagues. In Tibetan terms, those images would simply be treated as *par*, or copies of the real world, rather than *rten*, objects imbued with aura due to the sacred nature of the bodies they reference. Of course, we cannot know whether he also intended to create portraits of himself or the Panchen Lama for devotional purposes, but this does not seem beyond the realm of possibility.[16] As mentioned earlier, the founder of a Tibetan monastery in Darjeeling, Sherap Gyatso, had certainly visited a studio photographer in the 1890s, had allowed his portrait to be converted into a postcard and may well have presented copies of this postcard to his fellow Buddhists as photo-icons. Since colonial Darjeeling was a place where relationships between leading figures in the Tibetan community, members of the British civil service and the photographic fraternity were forged, novel transcultural forms could readily emerge there.

Darjeeling was still a hub of Anglo-Tibetan interactions when the 9th Panchen Lama arrived in the town in 1905. At that time, he was being courted by the British government, who hoped he would act as an ally while relations with the 13th Dalai Lama remained tense following the violence of the Younghusband Expedition of 1903–4. The Panchen Lama's visit to India culminated in a meeting with the viceroy in Calcutta, but before that he paused for some time in Darjeeling and took the opportunity to be photographed by John Burlington Smith (illus. 88). However, the monk was apparently not able to venture as far as a photographic studio and Burlington Smith therefore had to devise an innovative method for picturing a Tibetan reincarnate ensconced in his temporary residence at the Drum Druid hotel in a British hill station. The resulting portrait shows how an improvised throne of floral sofa cushions was assembled and positioned in front of the fireplace in a high-ceilinged drawing room. Perched upon it, and with his back to a large mirror, the Panchen Lama looks uncomfortable. But then, many things about this composition are slightly awkward, not least because the photographer had to position himself at an oblique angle in order to avoid appearing in the mirror's reflection. The editor of the London illustrated magazine *The Graphic* was delighted with the outcome, however, and excitedly announced to his readers: 'Photographed for the first time: The Tashi Lama of Tibet'.[17]

Although this image would be construed as a triumph in the British press, from a Tibetan point of view it was perhaps less pleasing. Quite apart from the makeshift seating arrangements and trappings of Britishness, the body of the Panchen Lama was not presented completely symmetrically and it could therefore not function as an icon in Buddhist usage. It was only when the 13th Dalai Lama reached Darjeeling five years later that a more appropriate and effective depiction of a living reincarnate could be manufactured for Tibetan Buddhist purposes.

By 1910 relations between Thupten Gyatso, the 13th Dalai Lama, and the government of imperial India had begun to improve. Hence when the Tibetan leader needed to flee before a substantial contingent of Chinese troops arrived in Lhasa, the British offered Darjeeling as a safe haven and a senior civil servant to handle the diplomatic and logistical arrangements. The man deputed for the task was Charles Bell and it was during Thupten Gyatso's long stay in India that the bond between the two men was first sealed. It would endure for the rest of Bell's career and allow him to document the life of the Dalai Lama both textually and photographically. In fact, it is in the pages of Bell's book *Portrait of a Dalai Lama* that we are told how he took the first photograph of Thupten Gyatso 'seated in the Tibetan fashion'. Bell also relates that the 13th Dalai Lama then presented copies of it to monasteries and 'deserving people' who rendered to it 'the worship they gave to images of Buddhas and deities'.[18] It was thus undoubtedly Bell who instigated the process in which photography was identified as an invaluable medium for the Tibetan leader to communicate with his followers.[19] However, the Dalai Lama then decided to call upon the skills of a professional photographer and to indigenize the products of the colonial camera. Examining some of the many prints and postcards featuring the 13th Dalai Lama that were published under the name of Thomas Paar, it seems that His Holiness actually enlisted the services of the most successful studio photographer in Darjeeling in the early twentieth century.[20]

However, the Dalai Lama would not be photographed in Paar's studio but in a religious setting, where the backdrop and props would be appropriately Buddhist.[21] The presence of *thangka* (scroll) paintings, Tibetan textiles and a proper monastic throne – as opposed to a pile of cushions – coupled with the hieratic portrayal of the Dalai Lama's body, all serve to create an image that concurs with the criteria of Tibetan

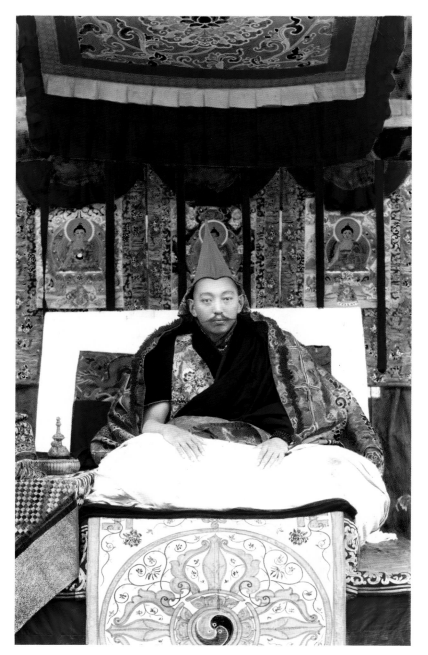

89 Thomas Paar and a Tibetan painter, the 13th Dalai Lama, probably Kalimpong, 1912, hand-tinted silver print.

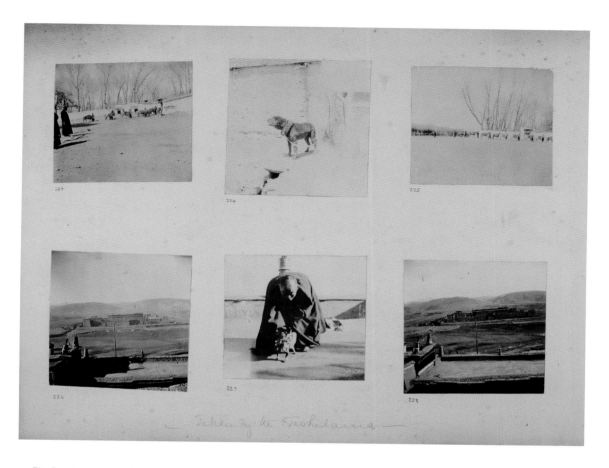

90 The Panchen Lama, 'taken by
the Tashi Lama'; photographs of
his monastery at Shigatse in the
album of Frederick Marshman
Bailey, between 1905 and 1907,
silver prints on card.

Buddhist aesthetics. Paar's work was Tibetanized even further when the Dalai Lama requested that it should be hand-coloured by a Tibetan painter in his retinue, though tellingly the parts of his body that mark out the identity of an individual – most importantly, the face – remain visible in black and white in the finished prints. In fusing the mimetic qualities of photography with the authenticating aesthetic of a Tibetan painter's pigments, the Dalai Lama converted a *par* into a *rten* and essentially invented the Tibetan photo-icon.

It has therefore been established that a number of senior figures in Tibetan Buddhism became either subjects or patrons of photography from the late nineteenth century onwards, but let us now to briefly turn to an even less well-known topic: the history of their own experiments with cameras. Since no record of the Sengchen Lama's endeavours in this regard exist, the photographs produced by the 13th Dalai Lama and the 9th Panchen Lama that I discovered in British archives are therefore extremely important. Among the numerous volumes in which the intelligence officer Frederick Marshman Bailey pasted the photographs he had generated during multiple journeys to Tibet between 1904 and 1928, one album preserves a

92 Tai Situpa Rinpoche, 'Gentle Blessing', Taiwan, 1996, colour film negative.

91 The 13th Dalai Lama's staff with his palanquin, captioned in Bell's handwriting, 'photographed, processed and developed by the DL [Dalai Lama] himself', probably taken in Kalimpong in 1912, from the collection of prints that belonged to Charles Bell.

set of prints with the caption 'taken by the Tashi Lama'. Clearly Bailey had handed his camera over to the Panchen Lama, since they feature shaky shots of his fellow monks, his pets and views from the roof of his monastery at Tashilhunpo (illus. 90). Within Charles Bell's private collection of prints are some tentative attempts made by the 13th Dalai Lama to record the appearance of his state palanquin and members of his entourage in India (illus. 91). These pictures seem to have been taken with Bell's camera in the grounds of Bhutan House during the Dalai Lama's visit to Kalimpong, a small town near Darjeeling, in 1912. However, one of Bell's first gifts to this Dalai Lama when they met in Darjeeling in 1910 had been a camera and six dozen glass plates, so it is also possible that the monk had been printing and developing the results of his own camerawork since then.[22] More recently, high reincarnates such as the 17th Karmapa and Tai Situpa have become accomplished photographers, although the former told me in 2012 that since he was largely confined to his monastery in India, he suffered from a restricted range of subject matter.[23] Tai Situpa, on the other hand, has been able to take his camera all over the world during his travels to give teachings to his many foreign acolytes. Since he is also a painter and calligrapher, not to mention a renowned Buddhist adept, his elegant photographs of plants, animals and other aspects of nature have a pared-down, meditative quality (illus. 92). In their simplicity of form and haiku-like captions, they suggest that a 'Tibetan Buddhist' photograph need not only be a record of the body of a reincarnate. It can also be an object that is thought to transmit the radiance of his or her mind.[24]

'Tibetan' Photography

Once their religious leaders had set a precedent, in the early years of the twentieth century other Tibetans begin to take up photography. However, this was hardly a widespread movement and photography would not become what Pierre Bourdieu has called a 'middlebrow' art in Tibet until much later, when economic conditions allowed something approximating a middle class to emerge in the 1980s.[25] To begin with, only wealthy individuals with connections outside the country could take up the hobby with some ease. For example, the daughter of

a minister in the Tibetan government, Rinchen Dolma Taring, informs us that her father acquired his first camera during a visit to Calcutta in 1907, when he was ordering a shipment of sewing machines to sell in Tibet. In her memoir she states that neither cameras nor sewing machines had been seen in Lhasa before.[26] Since the Russian Tsybikov had secretly pictured the city in 1900, cameras may well have been invisible to Tibetans at that point. By 1910, however, they were certainly being used commercially in the Tibetan capital and especially by individuals from neighbouring regions. A Ladakhi Muslim known only as 'Ishmael la' was popular in Lhasa's smart social circles, since he made house visits to take portraits, and a photographer from Nepal, Bhalpo Nadi, had established a studio in a central location.[27] A little later, Demo Rinpoche, a nephew of the 13th Dalai Lama and a reincarnate monk himself, is said to have nurtured his interest in photography with help from a Nepalese friend who worked at such a place.[28]

Other elite figures who were experimenting with photography in this period honed their skills among Europeans. As we heard in Chapter One, Sonam Wangfel Laden La was one of them. He had been a vital asset to Thomas Paar when Paar had sought to picture Tibetans in Buddhist environs in Darjeeling in the 1890s; Laden La assisted him not only by posing for the Englishman but in facilitating access to those places. No doubt the young man absorbed a good deal of knowledge about photography in the process. By 1911, when Laden La had the chance to travel into Tibet, he was clearly pursuing the practice independently and yet still seeking advice from others. According to his biographers,[29] he took his first pictures at Gyantse with the help of Sergeant Henry Martin, a telegraph operator who had stayed on after the end of the Younghusband expedition and produced hundreds of photographs.[30] Laden La's endeavours with his camera in Tibet mean that he was among the first individuals of Tibetan heritage to photograph within the country (illus. 93). By 1918 a number of others were following in his footsteps, as Eric Teichman witnessed during a tour of eastern Tibet. The British consular official reported that generals in the Tibetan army had 'in most cases visited India' and 'carry Kodaks'. He also observed that

these Tibetan officers from Lhasa and Shigatse, whom the Chinese profess to regard as savages, are nowadays more civilised and better

acquainted with foreign things than their equals in rank among the Chinese military of Western Szechuan.[31]

It is hardly possible to make generalizations about the rise of 'Tibetan photography' in this period given the minute numbers of photographers involved, the limited access to their work (due to restrictions on entry to archives in Tibet in recent decades) and the difficulty of reconstructing the context of their creation as a result of the loss of information about the materials that are now archived outside Tibet. However, the imagery generated by a small coterie of upper-class photographers that is currently available to us indicates that they generally used their cameras in the same way that most amateurs do: to depict their families, their friends, their property and their social gatherings. Some also recorded ceremonies and religious occasions, while others concentrated on their professional milieu. Dundul Namgyal Tsarong, for example, took pictures of his comrades in the Tibetan army as they tested their weapons in the plains outside Lhasa. He

93 Sonam Wangfel Laden La, display of a large banner depicting the Buddha at the monastery of Sera, near Lhasa, around 1911, copy-print from worn glass plate.

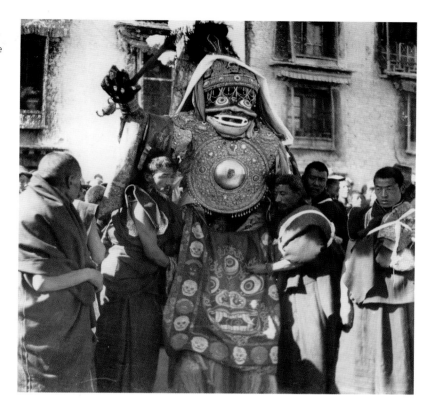

94 Dundul Namgyal Tsarong, the goddess Palden Lhamo, protector of Tibet, being paraded around the streets to grant her blessings on the populace, Lhasa, 1946.

also photographed the effigy of Palden Lhamo, protector goddess of Tibet, as she was paraded through the streets of Lhasa.[32] It would therefore be hard to argue that there is anything distinctively 'Tibetan' about the local modes of photography that were pursued in the country between the 1910s and the 1940s. All we may be able to detect are slight differences in the content of photographs by Tibetans, when compared to those of the foreigners who visited Tibet in the same period, and perhaps a variation in tone, when both photographer and subject are Tibetan. This is occasionally observable in the output of Tseten Tashi, a man of Tibetan/Sikkimese heritage who, according to the information currently available, was the only person from such a background to establish a photo-studio before 1959. He did so in the 1940s at his hometown of Gangtok in Sikkim, using a Rolleiflex acquired indirectly from a member of the Schäfer expedition to Tibet of 1938.[33] The

'Tse Ten Tashi & Co.' *parkhang* (literally meaning 'house of copies') quickly became a thriving business by creating portraits of the residents of Gangtok for passports, identity cards and other purposes. Customers could also purchase prints and postcards of its owner's landscape studies and illustrations of major events in the religious and royal calendars of the eastern Himalayas. Since he was secretary to the *chögyal* (king) of Sikkim

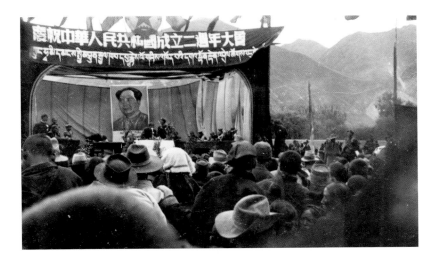

95 Tseten Tashi, ceremony held in Lhasa to mark the 2nd anniversary of the birth of Communist China, 1951, silver print.

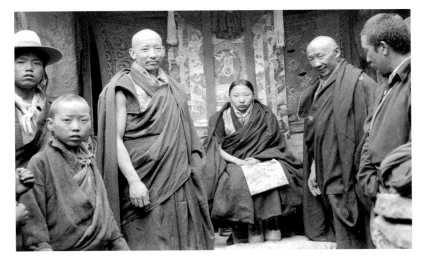

96 Tseten Tashi, Dorje Pagmo, the head of Samding monastery, with entourage, 1951, silver print.

97 Tseten Tashi, the 14th Dalai Lama, walking down a street in a southern Tibetan town, probably Yatung, 1951, silver print.

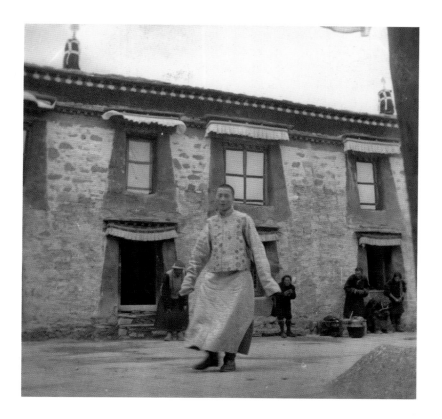

and 'court photographer' to the monarchs of both Sikkim and neighbouring Bhutan, Tseten Tashi was in an ideal position to document life in those areas. In 1951 his connections in high places also presented him with a particularly special opportunity. He was invited to follow the 14th Dalai Lama on his return journey to Lhasa after a protracted stay in Yatung (or Dromo) in southern Tibet. While on that assignment, Tseten Tashi created a rich visual account of the country, which is exceptional for the fact that a Tibetan has made it, as well as for some of its content, such as his pictures of the ceremonials held in Lhasa to mark the second anniversary of the birth of Communist China (illus. 95).[34] In addition, his portraits of his fellow Buddhists are notably less formal than those of foreign photographers, as is evident in the relaxed expressions of the attendants of the female incarnate, Dorje Phagmo, at her monastery at Samding (illus. 96). Tseten Tashi's

depiction of an even more illustrious figure, the 14th Dalai Lama, apparently strolling freely down a street in Tibet without any guards, simply could not have been taken by anyone other than a trusted co-religionist (illus. 97). But if an impression of liberty can be derived from that picture, it is a false one. In May 1951 the 'Seventeen-point Agreement' on the future of Tibet was ratified in Beijing by Mao Zedong and Ngabo Ngawang Jigme, the senior official representing the Tibetans. This agreement effectively ceded control of the Dalai Lama's domain to China. By October of that year the battalions of the People's Liberation Army were marching into eastern Tibet.[35]

The Camera as Weapon

From the perspective of the Chinese government, the 'Peaceful Liberation of Tibet' was achieved in 1951, but arguably their full control of the country was not gained until 1959 when the 14th Dalai Lama departed for India. In the early 1960s he was followed into exile by thousands of other Tibetans, though millions stayed on in Tibet and experienced at first hand the dramatic transformations that Maoism would bring. This is not the place to analyse the effects of China's dominance of a region they deemed to be a feudalistic fiefdom, where abject devotion to Buddhism had kept its residents in a perpetual state of backwardness, nor is there space to discuss the variety of Tibetan reactions to it. Suffice it to say that in the decades that followed, Maoist modernization policies would be rigorously implemented in order to bring Tibet fully into the fold of the People's Republic. During the Cultural Revolution (1966–76) in particular, the vestiges of ancient Tibetan religious, cultural and social practices were excised as the national campaign to remove the 'Four Olds' (old customs, old cultures, old habits and old ideas) was firmly enforced. Unsurprisingly, the production of photography by Tibetans during this period appears to have all but ceased. The archives are certainly largely silent in this respect. However, one highly potent image from 1966 articulates the reasons for the demise of Tibetan photography, and much else besides (illus. 98). It shows Demo Rinpoche, one of the early Tibetan aficionados of the camera, and his wife during a 'struggle session' in Lhasa. Having failed to renounce his faith in Tibetan Buddhism or to destroy sacred objects in the shrine room of his home, Demo had been forced

by the Red Guards to wear a sign on his head that stated 'Down with the reactionary landowner Tenzin Gyatso' (that is, the 14th Dalai Lama). He was then paraded through the streets, displaying the paraphernalia of his elevated social and religious status, in order to be denounced by the baying crowds. Demo stood accused of three crimes: that he was a 'reincarnate Buddha', that he had communicated with the exiled Dalai Lama and that he owned a 'dangerous' camera.[36] Two such dangerous weapons that he owned were hung around his neck, no doubt to remind onlookers of their capacity to convey messages that did not confirm Maoist ideology.

Demo Rinpoche was not the only Tibetan whose absorption in a 'decadent' pastime like photography caused him to be purged for his 'rightist'

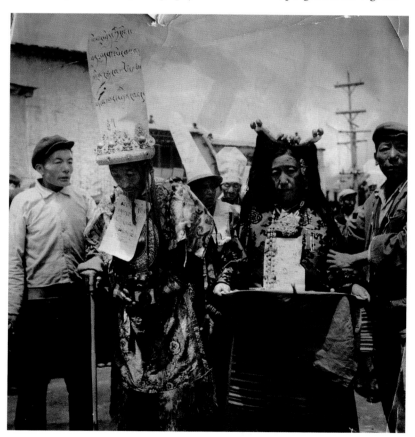

98 Unknown Chinese photographer, Demo Rinpoche and his wife during a struggle session in the streets of Lhasa, 1966, from *Photographers International*, xxxix (1998).

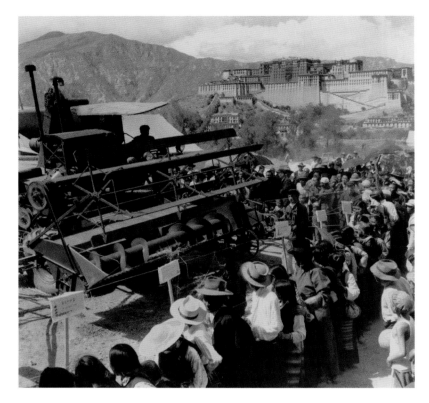

inclinations. Oral testimony relates that members of other aristocratic families in Lhasa often destroyed their photographic equipment and collections during the Cultural Revolution in order to avoid a similar fate. This is just one of the many reasons why it is difficult to delineate the history of photography by Tibetans in Tibet both prior to 1959 and afterwards. Plus, for the period after the Dalai Lama's move to India, the obliteration of Tibetan family archives created a vacuum that has since been filled by the visual documentation produced by Chinese photographers, and which has begun to be republished and exhibited in China in recent years.[37] Since the majority of it was generated by party cadres, members of the army and government officials who were posted to Tibet from the 1950s onwards, the pictures are often composed in Socialist Realist style and accompanied by the kind of propagandistic commentary demanded by the journals in

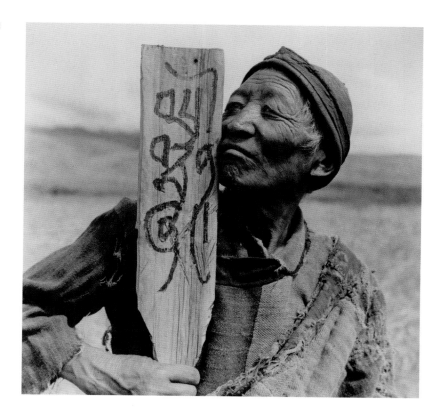

which they were first published, such as *Tibet Reconstructs* and other English-language organs, in which the Chinese Communist party spread word internationally of its reforms in Tibet. It must be said, however, that some Chinese photographers with training in journalism or fine art did occasionally manage to craft images that were less laden with ideological overtones. But their depictions of Tibetans are often not dissimilar from the 'type' photography created by Europeans in the nineteenth and early twentieth centuries, since they too reflect a colonialist preoccupation with all that was thought to be appealingly alien about Tibet. This comparison is not as far-fetched as it may seem, since in Chinese anthropological constructions of race, the 'minority' inhabitants of the People's Republic, including Tibetans, are positioned at the lower levels of an evolutionary pyramid while the Han are at its peak.

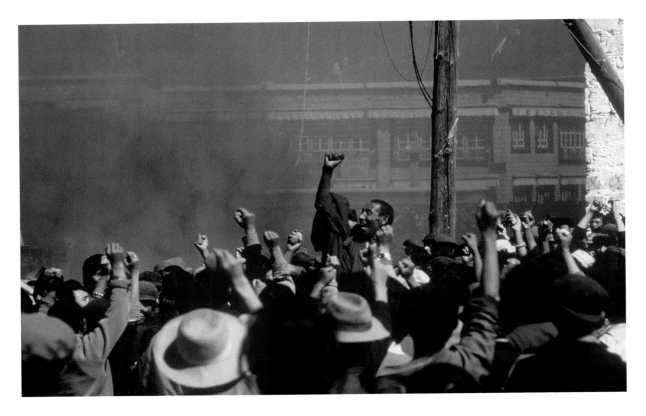

101 John Ackerly, Jampa Tenzin, supported by the crowds during a demonstration in Lhasa, 1987, colour film negative.

If the photographic representation of Tibet after 1959 once again fell into the control of outsiders, though this time from the East rather than the West, it did so because the Chinese administration had identified the camera as a potential threat to their authority (as Demo Rinpoche and his ilk had discovered to their cost). Every effort was made to ensure that very few foreign photographers had access to Tibet in the post-Liberation period. In the 1960s and '70s, only those who could be trusted to toe the party line would be granted such an opportunity.[38] But in the mid-1980s the state began to lift such proscriptions and encouraged foreign tourism, particularly to the Tibet Autonomous Region, as south-central Tibet (U-Tsang) had been named since 1965. Under premier Deng Xiaoping, policies constraining religious practice among Tibetans were somewhat relaxed and economic development was promoted. The initial result in terms of photography was a surge in

travel-style reportage and romantic portrayals of elderly Tibetans as they returned to their prostrations and circumambulations of Buddhist sites. When such pictures were published internationally they hinted that Tibet had regained some of its Shangri-La qualities and that the horrors of the Cultural Revolution could begin to be forgotten. Nevertheless, there was also a potential downside for the Chinese government in the opening of Tibet to the camera: it could be used to document dissent and revolt. When Tibetan monks began to demonstrate against Chinese rule in Lhasa in 1987, their actions and the violent response of the security forces were caught on film. Western photographers, whether present in Tibet for professional or touristic reasons, swiftly despatched their pictures to news agencies and authenticated the story of a Tibetan uprising that China would rather not be told. In particular, John Ackerly's shot of a monk called Jampa Tenzin, with his arm raised and fist clenched, being carried aloft by a crowd of Tibetans after the police had assaulted him, became a summarizing symbol for the events of that year (illus. 101).[39] Its publication meant that after almost thirty years of absence from the international news agenda, the political situation in Tibet was brought firmly back into view. Ackerly's picture also made the dangers of photography only too apparent to those within the PRC who sought to control both it and Tibet.

The Camera as Mirror

In the climate of strict control over image-making that has prevailed in the Tibetan-speaking regions of the People's Republic since that time, it is hardly surprising that the development of 'Tibetan photography' has stalled. This is not to suggest that Tibetans do not take pictures. They undoubtedly do, but opportunities to present them to anyone other than family or friends in exhibitions, print culture and the media are restricted. Only a limited range of imagery can enter the public domain with some ease. Since the 1990s, elegiac panoramas of the grasslands of eastern Tibet or the wilderness of the Changtang have featured in *Tibet Geographic*, just as they have in *National Geographic*, the American journal that the Chinese publication seeks to emulate. While both Tibetan and Western

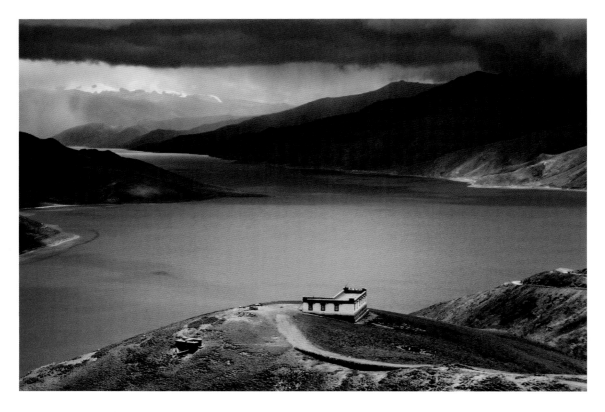

photographers have undoubtedly intended to celebrate the beauty of the Tibetan landscape in such work, it could be said to have had the unintended consequence of supporting the Chinese government's drive to increase domestic and foreign tourism in Tibet. Similarly, the poignant portraits of men, women and children crafted by art photographers such as Phil Borges, Steve McCurry and perhaps the most famous Western follower of the Dalai Lama, the actor Richard Gere, are clearly inspired by sympathy for the Tibetan people. However, if they encourage international travellers to make a touristic pilgrimage to Tibet, those images risk contributing to the enrichment of the coffers of the People's Republic and confirming its presentation of Tibetans as a charmingly picturesque but essentially backward 'minority'.[40] Meanwhile it remains difficult for Tibetans themselves to enter the worlds of reportage, social documentary or fine

102 Steve McCurry, 'Yamdrok Tso Lake', southern Tibet, 2004, digital C-type print.

103 Phil Borges, 'Yama, aged 8', Tibet, 1994, tinted black-and-white print.

142

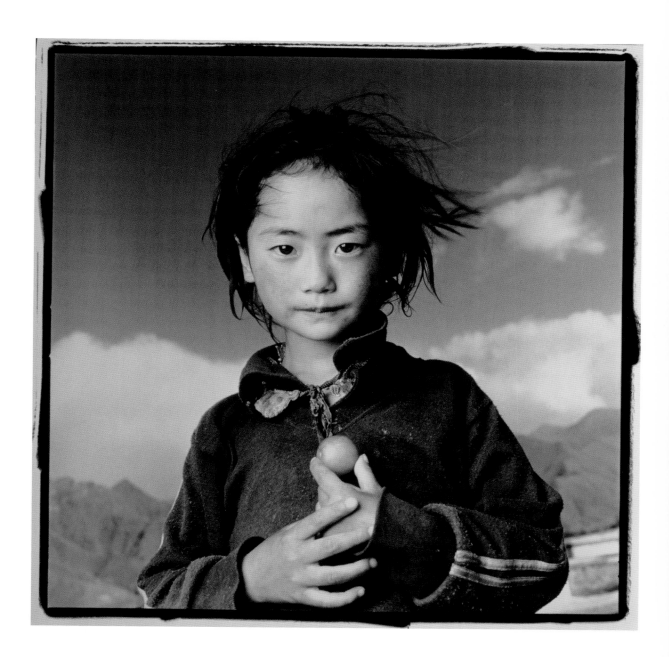

art photography, either in China or within the diaspora. This makes the individuals referred to in the following pages all the more remarkable.

For the young Tibetans who are currently exploring photography as a medium of self-expression, it seems that the camera is most valued as the creator of *par*. They see it as a device best suited to replicating the realities of Tibetan lives, whether in Tibet or in exile. Though a cliché in other contexts, the idea that photography mirrors the world has a particular pertinence in a situation where those realities are perceived to be unknown to outsiders and when both photographers and members of their community consider themselves to be disempowered. Such points have been made in sophisticated form by the Tibetan artist Tenzing Rigdol in a work he titled

104 Tenzing Rigdol, *Melong* (Mirror), New York, 2013, paper and silk brocade collage on canvas.

Melong, or 'mirror' in Tibetan. The child of Tibetan refugee parents who was born in Nepal in 1982, Rigdol is now based in New York and has become one of the leading figures in a transnational Tibetan art movement.[41] *Melong* is essentially a collage made from silk brocade, paper (printed with text in Tibetan and English) and a mass of photographic imagery extracted from books, newspapers and the Internet. Its composition is derived from the *srid pai khor lo*, or wheel of cyclic existence, a didactic design in which the wheel is held in the tight grasp of Yama (the lord of death) as he assesses the karmic future of all sentient beings. When painted on the walls of Tibetan temples, it was designed to illustrate the vices that Buddhists should avoid, the virtues they should embrace and the fate that may befall them as a result of their life choices. In brief, the wheel shows the movement of the soul through the cycles of life, death and rebirths within different domains, ranging from a hell of perpetual fire to the bliss of a Buddhist paradise on earth. Rigdol has reinterpreted this format and message in a variety of ways, most notably by encircling its central imagery with a rim of flames and fire extinguishers. Since this piece was made in 2013, when the number of individuals who had self-immolated in Tibet was increasing rapidly, his desire to comment on the desperation felt by many Tibetans within China is clear. It is likely that this is also why the work is called 'mirror' rather than 'wheel', and why photography is the principal medium through which Rigdol's intentions are communicated.

To create this piece the artist collected hundreds of small pictures, mainly alluding to the fraught history of Tibetan–Chinese relations after 1959 and the conflagrations it had ignited, which he then divided into four domains. On one side are the massed ranks of Chinese troops while opposite them are protestors in exile wrapped in the Tibetan flag that is prohibited in the PRC. The bottom section is filled with the iconography of an independent Tibet, from postage stamps issued in the period of the 13th Dalai Lama to the palace at Yarlung, the residence of the Buddhist kings of Tibet since the seventh century. At the top, and hence in a position traditionally reserved for figures of the greatest sanctity, Rigdol has canonized the heroes of the Tibetan cause, whether monks or lay people, men or women. He has included artists, writers, scholars, activists and of course, the 14th Dalai Lama. Far more could be said about this work but the key point here is that its force is dependent upon the indexicality of photography. Since the artist has usually worked

with paint, film and, on one important occasion, with 20,000 kilograms (44,000 lb) of soil that he had smuggled out of Tibet to India for an installation in McLeod Ganj called 'Our Land, Our People', this deviation into photographic realism for *Melong* was a deliberate choice.[42] Its lessons could not have been delivered without the notion that the camera creates faithful copies (*par*) that literally reflect what Rigdol sees as the true story of Tibet in the twenty-first century.

A number of other Tibetan contemporary artists who previously worked in more painterly modes have also recently turned to photography. For example, in 2008 Tsewang Tashi, a senior lecturer at Tibet University Art School in Lhasa, created a set of large-format digital prints that he dubbed his 'Shangri-La' series.[43] They consist of heavily staged portraits of residents of Lhasa that seem designed to deflect expectations of Tibet as a haven of Buddhist traditionalism. One shows four elderly Tibetans prostrating outside a temple while a tourist points a massive lens in their direction. Another features a smiling hostess from a *nangma* nightclub in a silver mini-dress, emblazoned with the logo of an American beer company, greeting a man dressed in sheepskin-lined gown (illus. 105). The contrast in their attire seems designed to make the complex effects of modernization, Sinicization and globalization on the city only too apparent. What is not so clear is that this series was actually inspired by the paintings of a Han Chinese artist, Chen Danqing, who lived in Tibet in the 1960s and '70s and specialized in portraits of Tibetans who had been neither modernized nor Maoized.[44] Tsewang Tashi's reworking of a leading Chinese artist's oeuvre from the period of the Cultural Revolution raises all kinds of questions about how Tibetans respond to outsiders' depictions of themselves, and whether his art is designed to elicit regret or delight at the changes that outside forces have initiated.

Over the last decade or so, the international art world has provided a platform for artists of the Tibetan diaspora and some from the Tibet Autonomous Region to pose such conundrums to non-Tibetan audiences.[45] Unfortunately, for the small group of Tibetans for whom photography is their primary medium, an outlet of that sort is not yet available to them. These closing pages will therefore present the work of three young photographers whose pioneering work is emblematic of what one can only hope will become a wider movement in the future.

105 Tsewang Tashi, 'No. 2' in the series *Shangri-La*, Lhasa, 2008, digital C-type print.

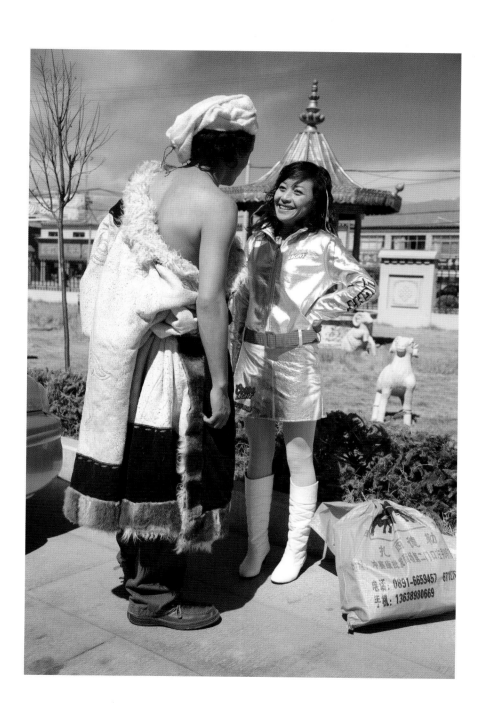

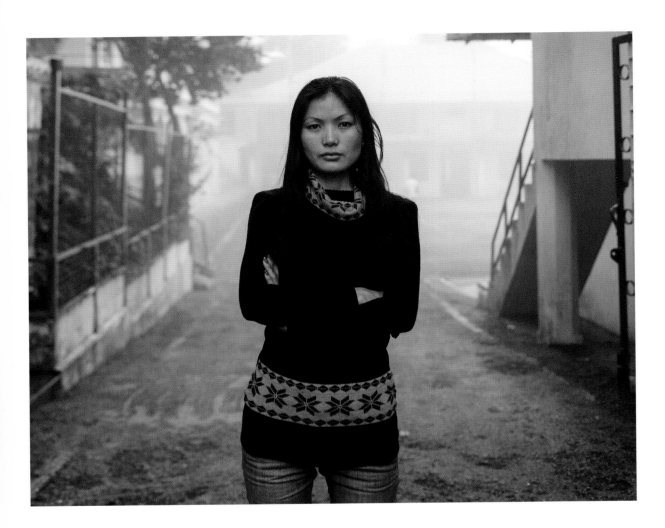

107 Tenzing Dakpa, 'Model of the Potala', Bylakuppe, India, from the series *Refuge*, 2008, digital C-type print.

106 Tenzing Dakpa, 'Portrait of a Girl', McLeod Ganj, India, from the series *Transit*, 2012, digital C-type print.

Tenzing Dakpa grew up in Sikkim but completed his education in the Indian capital, New Delhi. He studied photography and advertising there and soon found a job working as a fashion photographer. However, his frustration with the superficiality of that world and the pressures of living in an Indian city (where he felt that his identity as a Tibetan refugee, a man from the hills, and as an artist was constantly being questioned) meant that art photography offered something of a respite and the freedom to reinvent himself in a creative space.[46] He therefore began to document the lives of others in a similar position to himself and produced a set of melancholic portraits of his friends and neighbours that articulated the alienating effects of the urban environment and the experience of exile that they shared (illus. 107). He then inserted those images into an intervention in the streets of Majnu ka Tilla, the New Delhi enclave where many Tibetans reside. Dakpa attached his prints to

149

109 Nyema Droma, young Tibetan man, London, 2014, digital C-type print.

108 Nyema Droma, two men drinking beer, Lhasa, 2012, digital C-type print.

walls, pavements and roads, and left them to blister in the sun or be tramped on by passers-by. The fact that they were ignored and then destroyed by the heat and incessant movement of the city was his statement on the transience, emptiness and invisibility of the lives of many exiled Tibetans in India.

Another talented young innovator is Nyema Droma from Lhasa. In 2012 she left Tibet to take up a place at the Central St Martins school of art in London. She studied fashion photography there and soon found work in that field but, like Dakpa, Droma has also conducted artistic experiments with her camera and has concentrated on portraiture. Her pictures of friends and family project new modes of being Tibetan: whether as consumers of global commodities in Lhasa or as hipsters who are utterly at home in a multi-cultural city like London. Rather than being the objects of an exoticizing regard in a foreigner's catalogue of ethnicities, Nyema Droma's subjects are individuals who play with the stereotypes of Tibetanness, adopting or discarding them as swiftly as a catwalk model changes clothes.

Finally, though he lacks art school training and sells his work on makeshift roadside stalls, Jigme Namdol is another young photographer with great imagination and resilience. In its mobility and rootlessness, his biography reflects the history of Tibet after 1959. Born in Lhasa in 1983, Namdol came to India as a child and attended the Central School for Tibetans in the Tibetan 'capital in exile' at McLeod Ganj. His mother remained in Lhasa and he has only been able to communicate with her infrequently. Her son manages to survive in India as a self-taught photographer with an itinerant lifestyle, roaming from place to place and selling his prints whenever and wherever he can. Upon meeting him in 2015, his prints were displayed on wooden planks in the main bazaar in McLeod

Ganj as cars, cows and shoppers squeezed past. Alongside were his precious cameras: a Yashika and a Rolleicord, both dating from the 1960s and requiring film that could only be purchased in Delhi or Calcutta. Namdol stated that he preferred the qualities of old cameras and that by printing onto cotton paper he aimed to replicate the textures of an earlier era in photography. He applied this principle to all the subjects he documented during his travels throughout India, which included, but were by no means limited to, the Tibetan refugee community.

When asked about one of the prints he had on display and that appeared to feature Tibetan-style buildings and two figures in Tibetan dress, Namdol recounted the story of its creation. In 2012 he had attempted to return to Tibet and had ventured as far as Mustang, which was at one time a minor Tibetan principality but is now part of Nepal. He knew that for a Tibetan who lacked a passport, crossing the border between Nepal and Tibet was illegal, but he continued to walk towards it with his camera at hand. Just a few miles from Tibetan territory Namdol sensed that the Nepalese police were nearby and so he quickly used up the film, removed it from his camera and hid the film canister in case he was arrested. The photograph he now calls 'Road to Tibet' was the last one he took before the border police intervened and his mission had to be aborted. That simple but beautiful image conveys a personal story of separation from his mother, coupled with the collective experience of estrangement from the homeland that Namdol shares with many other Tibetan refugees in India.[47] In capturing an impression of a place that was almost Tibet but not quite, it also signifies their dream of return. 'Road to Tibet' thus brings us back to the beginning of this book and the first photographs taken in Tibet. In 1863 the British colonial officer, Philip Egerton, traversed the border of a country that was not his own, snatched a couple of images of it and was promptly ejected. A hundred and fifty years later, when a young Tibetan tried to reach his motherland, he too was prevented from doing so and left merely to record the road not taken. Once again, Tibet was tantalizingly close but ultimately inaccessible and unphotographable – even for a Tibetan.

110 Jigme Namdol, 'Road to Tibet', Mustang, Nepal, 2012, black-and-white print on cotton cloth.

Epilogue

Of course, the most important arenas in which photographs of Tibet currently circulate and perform are the Internet and social media. Along with the majority of people on the planet, many Tibetans have access to smartphones or cheap digital cameras. The ready availability of such devices enables them to distribute pictures among friends and family, and to bridge the chasm between Tibet and its diaspora by communicating visually in cyberspace. Some young Tibetans within the People's Republic are using the freedoms that the Internet affords to post visions of alternative Tibetan lives, while those outside China are contesting visual representations that they consider to be untruthful and creating new ones to take their place. At both local and global levels, photography continues to play a role in challenging myths generated about Tibet in the past, in articulating commentaries on the reality of its present, in presenting fantasies about its future, and much else besides.

During the completion of this manuscript in April 2015, a set of 'Tibetan wedding pictures' went viral. They had been created by a Tibetan couple from the city of Chengdu who had chosen to portray themselves in a variety of sartorial modes and at different locations as they prepared for their nuptials. Gerong Phuntsok and Dawa Drolma appeared in sharp suits outside a high-end retail outlet in an ultra-urban environment, in nomadic dress peeping out of a tent in a countryside setting and in chic updated versions of 'traditional' Tibetan clothing as they climbed the grand flight of stairs that approach the Potala Palace in Lhasa. Within days of the release of these skilfully orchestrated pictures, 80 per cent of users of Weibo (the main social networking website in China) had seen them, constituting millions of

111 Gerong Phuntsok and Dawa Drolma at the Potala palace, Lhasa, digital photograph as it appeared on the Internet in 2015.

112 Gerong Phuntsok and Dawa Drolma in the city (probably Chengdu), digital photograph as it appeared on the Internet in 2015.

viewers. That number expanded exponentially and into global dimensions when international news outlets such as CNN, the BBC, the *New Yorker* and the *Indian Express* covered the story. Commentary on the glamorous Tibetan couple's pictures was therefore generated in many quarters and a wide range of views were expressed. They certainly inspired divergent responses from diasporic Tibetans on Facebook and Twitter. Some applauded the idea that Tibetans living in the People's Republic could toy with their identities and reference the past while also embracing a consumerist present. Others argued that the pictures were a dangerous distraction from more pressing concerns, particularly relating to the rising number of Tibetans who had self-immolated and about whom the international media had rarely reported. For activists, it was the harrowing scenes of Tibetan bodies engulfed in flames that the camera should be recording and the Internet distributing, rather than the trivialities of matrimonial attire. Meanwhile, Han Chinese observers also interpreted the images in different ways. A college student from Xian wrote that 'the girl is pretty, but the Tibetan dark skin detracts from her beauty,' while a businessman in Changsha proclaimed that 'a few rich Tibetans hardly means the whole lot is sophisticated.'[1] The most positive response, however, appears to have come from youthful, fashion-conscious members of the Chinese middle class, who inundated the Tibetan couple with requests for the contact details of their photographer. To them, Tibet now looked like the perfect destination for a wedding photo shoot. Perhaps the last word should go to Gerong Phuntsok, who when asked to comment about the popularity of the pictures told Xinhua, the official state news agency of the PRC, 'Maybe we represented thousands of young people from ethnic minorities, who left their hometowns to pursue a "modern life" but chose to return to tradition after feeling a void in the heart . . . As we fight for our dreams, some of us get lost. So we wanted to say with the photos: stick to your beliefs.'[2] It seems that Gerong, Dawa and many other Tibetans could take solace from the chance to make Tibet anew photographically.

References

Prologue

1 Laurence Waddell, *Lhasa and its Mysteries: With a Record of the Expedition of 1903–1904* (London, 1905).
2 Francis Younghusband, from a letter to his superiors in government quoted in Patrick French, *Younghusband: The Last Great Imperial Adventurer* (London, 1994), p. 233.
3 On the general point see Susan Sontag, *On Photography* (New York, 1977).
4 There is, of course, extensive literature on the question of Tibet's independence or otherwise from China. See for example Elliot Sperling, *The Tibet–China Conflict: History and Polemics* (Washington, DC, 2004); Alex McKay, *History of Tibet* (London, 2003); and Zahiruddin Ahmad, *China and Tibet, 1708–1959: A Résumé of Facts: Chatham House Memoranda* (London, 1960).

one Picturing Tibet from the Periphery

1 For a study of European travel literature on Tibet, see Peter Bishop, *The Myth of Shangri-La: Tibet, Travel Writing and the Western Creation of Sacred Landscape* (Oakland, CA, 1992).
2 George Nathaniel Curzon quoted in Laurence Waddell, *Lhasa and its Mysteries: With a Record of the Expedition of 1903–1904* (London, 1905), p. 1.
3 Edmund Candler, *The Unveiling of Lhasa* (London, 1905), pp. 307–8.
4 Prior to this publication it has generally been assumed that the earliest photographs of Tibet were those made by Prince Henri of Orléans in 1889–90. See, for example, Lobsang Lhalungpa, *Tibet the Sacred Realm: Photographs, 1880–1950* (New York, 1983).
5 Philip Egerton, *Journal of a Tour Through Spiti to the Frontier of Chinese Thibet* [1864] (Bath, 2011), p. 12.
6 Ibid., p. vii.
7 Ibid.
8 Ibid., p. 98.
9 Ibid., pp. 82–4.
10 Ibid., p. vii.
11 Robert Melville Clarke, 'From Simla through Ladac and Cashmere', reprinted in *Early Photographs of Ladakh*, ed. Hugh Rayner [1865] (Bath, 2013), p. 22.
12 Egerton, *Journal of a Tour through Spiti*, p. 24. Egerton's companion was Augustus Wilhelm Heyde, a Moravian missionary whose long service at the mission station in Keylang, Lahoul, meant that he was fluent in Tibetan.
13 Ibid., p. 96.
14 Ibid., p. 70. Egerton took the *nono*'s remarks as evidence of 'unreasoning prejudice' against Europeans on the part of the Tibetans.
15 Heinrich August Jäschke joined the Moravian mission in Keylang in 1856. He became a noted linguist and Tibetologist.
16 Henry Godwin-Austen, 'Description of a Mystic Play as Performed in Ladak, Zascar, &c.', reprinted in *Early Photographs of Ladakh*, ed. Rayner, p. 88.
17 The *cham* commemorating the life and deeds of Padmasambhava is still performed annually at Hemis monastery to this day.
18 An early example of a stereoscope was displayed at the Great Exhibition in London in 1851 but the design perfected by Oliver Wendell Holmes in the United States later in the 1850s soon became the most popular model. By 1881 the American firm Underwood & Underwood had gone into mass production of stereoviews from around the world and at the height of their success were printing ten million a year.
19 Samuel Bourne, *Photographic Journeys in the Himalayas, 1863–1866*, reprinted and ed. Hugh Rayner [1863–87] (Bath, 2009), p. 21.
20 Ibid., p. 200.
21 Ibid.
22 Many historians of photography have worked on Samuel Bourne. See, for example, Gary D. Sampson, 'Unmasking the Colonial Picturesque: Samuel Bourne's Photographs of Barrackpore Park', in *Colonialist Photography: Imagining Race and Place*, ed. E. Hight and G. Sampson (New York, 2002); and Zahid Chaudhary, *Afterimage of Empire: Photography in Nineteenth Century India* (Minneapolis, MN, 2012).
23 Bourne, *Photographic Journeys in the Himalayas*, p. 13.
24 Ibid., p. 27.
25 Ibid., p. 57.
26 The Irish philosopher and statesman Edmund Burke published *A Philosophical Enquiry into the Origin of our Ideas of the Sublime and Beautiful* in 1757.
27 Christopher Pinney, *The Coming of Photography in India* (London, 2008), p. 27.
28 Clark Worswick has suggested that the author of these images was Frank Mason Good. His argument is published in H. Rayner, ed., *Frith's Photopictures of India Series: Views in Kulu and Spiti* (Bath, 2011), p. x.
29 For further information on the beginnings of photography in India, see Pinney, *The Coming of Photography in India*.
30 See John Falconer, '"A Pure Labor of Love": A Publishing History of *The People of India*', in *Colonialist Photography*, ed. Hight and Sampson.
31 J. F. Watson and J. W. Kaye, eds, *The People of India: A Series of*

Photographic Illustrations, with Descriptive Letterpress, of the Races and Tribes of Hindustan, 8 vols (London, 1868), Preface, n.p.

32 Many authors comment on the fact that this project was largely conducted in the aftermath of the 1857 uprising and therefore had significant political overtones. Chaudhary writes 'the violent revolt imparted a newer interest to India, requiring that officers travel the land in search of interesting subjects' for photography, in *Afterimage of Empire*, p. 5.

33 On the scale, impact and ideological underpinnings of colonial documentation projects see Thomas Richards, *The Imperial Archive* (London, 1996).

34 Watson and Kaye, *The People of India*, vol. I, p. 92. I have retained the original rendering of 'Bhotia' here. The later spelling, 'Bhutia', used in other parts of this book, is still used to refer to an ethnic group of the eastern Himalayas.

35 Having acted as Surgeon General from 1853–90, Simpson was knighted for his services to the empire in India. On his activity as a photographer see John Falconer, 'Ethnographical Photography in India, 1850–1900', *Photographic Collector*, I (1984), pp. 16–46.

36 There is no comprehensive list assigning authorship to the illustrations published in volume one of *The People of India* but many are by Simpson. Other photographers who had been stationed in the Himalayas (including Philip Egerton) supplied material for it.

37 We know that Simpson was able to travel to Bhutan, since he accompanied the envoy of the British government, Ashley Eden, to that small Himalayan Buddhist kingdom in 1864.

38 Edward Tuite Dalton, *Descriptive Ethnology of Bengal* (Calcutta, 1872), p. i.

39 Joseph Fayrer, of the Indian Medical Service and another amateur anthropologist, had proposed to mount an exhibition in Calcutta in 1865 in which 'typical examples' of the 'races' of India would be physically on display. See Christopher Pinney, *Camera Indica: The Social Life of Indian Photographs* (Chicago, IL, 1998). For an account of how an exhibition of this kind was eventually staged, see Saloni Mathur, 'Living Ethnological Exhibits: The Case of 1886', *Cultural Anthropology*, XV/4 (2000), pp. 492–524.

40 Marie Louise Pratt defines 'contact zones' as places where people of different backgrounds encounter one another but often in the context of drastic power imbalances. See her book *Imperial Eyes: Travel Writing and Transculturation* (London and New York, 1992). For a more detailed analysis of Darjeeling as a cosmopolitan hub of photographic activity see Clare Harris, 'Photography in the Contact Zone', in *Kalimpong as Contact Zone*, ed. M. Viehbeck (Heidelberg, forthcoming).

41 Laurence Waddell, *Among the Himalayas* (London, 1899).

42 Laurence Waddell, *The Buddhism of Tibet or Lamaism: With its Mystic Cults, Symbolism and Mythology, and in its Relation to Indian Buddhism* (London, 1895).

43 Johnston and Hoffmann founded their business in Calcutta in 1882 and had set up a Darjeeling branch by 1890.

44 The concept of 'visual economy' is explored by Deborah Poole in *Vision, Race and Modernity: A Visual Economy of the Andean Image World* (Princeton, NJ, 1997).

45 The illustration of Paar's Darjeeling studio comes from a postcard created by the photographer to advertise his wares and services. Note the Europeans standing at the entrance, the rickshaw pullers waiting for trade and the sign saying 'to the studio'.

46 David MacDougall argues that the practice of photography in nineteenth-century hill stations was strictly segregated on racial lines but the products of Thomas Paar's studio complicate this notion. See MacDougall, 'Photo Hierarchicus: Signs and Mirrors in Indian Photography', *Visual Anthropology*, V (1992), pp. 103–29.

47 For further information about Ani Chokyi, Ugyen Gyatso and Laden La, see Nicholas and Deki Rhodes, *A Man of the Frontier: S. W. Laden La (1877–1936), His Life and Times in Darjeeling and Tibet* (Kolkata, 2006).

48 Anon., *Illustrated Guide For Tourists to the Darjeeling Himalayan Railway and Darjeeling* [1896] (Bath, 2004), p. 40.

49 Ibid., p. 41.

50 Sarat Chandra Das, *A Journey to Lhasa and Central Tibet* (London, 1902).

51 For an account of the grim fate that befell the abbot and other Tibetans who assisted Das see Alex MacKay, 'The Drowning of Lama Sengchen Kyabying: A Preliminary Enquiry from British Sources', *Tibet Journal*, XXXVI/2 (2011).

52 See Chapter Three in Clare Harris, *The Museum on the Roof of the World: Art, Politics and the Representation of Tibet* (Chicago, IL, 2012).

53 White's memoir of his life in the Himalayas was published as *Sikkim and Bhutan: Twenty One Years on the North East Frontier, 1887–1908* (London, 1909).

54 Theodor Hoffmann and John Claude White, 'Explorations in Sikkim: To the North East of Kanchinjunga', *Proceedings of the Royal Geographical Society and Monthly Record of Geography*, XIV/9 (1892), pp. 613–18.

55 Additional information about John Claude White's career and many examples of his photography can be found in Kurt and Pamela Meyer, *In the Shadow of the Himalayas: Tibet, Bhutan, Nepal, Sikkim. A Photographic Record by John Claude White, 1883–1908* (Ahmedabad, 2005).

two: The Opening of Tibet to Photography

1 *Daily Mail* correspondent Edmund Candler called his account of the mission *The Unveiling of Lhasa* (London, 1905). He and other journalists frequently used the 'unveiling' metaphor in their reporting.

2 For an account of the expedition see Gabriel Bonvalot and Henri d'Orléans, *De Paris au Tonkin à travers le Tibet inconnu* (Paris, 1892).

3 Sven Hedin published voluminous accounts of his travels in Tibet with many of his own photographs. See for example *Central Asia and Tibet* (New York, 1903) and *Southern Tibet: Discoveries in Former Times Compared to my Own Researches in 1906–08* (Stockholm, 1916).

4 Tsybikov was not the only Russian to bring a camera to Lhasa. Arriving in the city slightly later, his Kalmyk colleague Ovshe Norzunov also took photographs that were published in *National Geographic*. For further information about them see Alexandre Andreyev, ed., *Tibet in the Earliest Photographs by Russian Travelers, 1900–1901* (New Delhi and Berlin, 2013).

5 English-language publications that featured Tsybikov's photographs of Lhasa include *Lhasa and Central Tibet: Smithsonian National Museum Report of 1903* (Washington, DC, 1904); 'Journey to Lhasa', *Geographical Journal*, XXIII (1904); and 'The Forbidden City of Lhasa', *The Strand Magazine*, XXVII (1904).

6 For a discussion of the Potala in European literature see Peter Bishop, 'The Potala and Western Place-making', *Tibet Journal*, XIX/2 (1994).

7 A classic study on this subject is Peter Hopkirk's *The Great Game: The Struggle for Empire in Central Asia* (London, 1992).

8 Lord Curzon made this pronouncement in a speech at the Guildhall in London. It was then quoted in an article titled 'Life in the Strangest of Lands' in the London magazine *The Sphere* on 20 July 1904.

9 Several leading members of the Tibet Mission published books about it on their return to Britain, including Perceval Landon, Laurence Waddell and Edmund Candler. In 1910 Francis Younghusband published his views on relations between *India and Tibet* with John Murray, London. For later studies see Patrick French, *Younghusband: The Last Great Imperial Adventurer* (London, 2004) and Charles Allen *Duel in the Snows: The True Story of the Younghusband Mission to Lhasa* (London, 2004).

10 From Arthur Hadow's letter to his mother, 3 April 1904. NHRM 5069, Royal Norfolk Regimental Museum, Norwich.

11 For a lengthier discussion of photography during the mission see Chapter Three in Clare Harris, *The Museum on the Roof of the World: Art, Politics and the Representation of Tibet* (Chicago, IL, 2012).

12 In the preface to the 1906 edition of his *Tibet and Lhasa* album, White wrote: 'The photographs were taken during the last Tibet Mission which was necessitated by the stupid obstinacy of the Tibetans.'

13 G. J. Davys's Tibet album is archived at the Royal Geographical Society in London.

14 This album by an unnamed member of the Royal Fusiliers is curated by the National Army Museum, London.

15 Benedict Anderson, *Imagined Communities: Reflections on the Origin and Spread of Nationalism* (London, 1991).

16 Davys's postcard is archived at the National Army Museum, London.

17 George Rayment's album is archived at the National Army Museum, London.

18 For a discussion of other negative features of this mission, especially related to looting, see Chapter Two in Harris, *The Museum on the Roof of the World*.

19 Anonymous review of Laurence Waddell's *Lhasa and its Mysteries* published in the *Times Literary Supplement*, 31 March 1905.

20 Candler, *The Unveiling of Lhasa*, pp. 307–8.

21 For 'visual economy', see Deborah Poole, *Vision, Race and Modernity: A Visual Economy of the Andean Image World* (Princeton, NJ, 1997).

22 Since the publication of Arjun Appadurai's edited volume *The Social Life of Things* in 1986 a substantial body of literature on commodities and the socio-cultural biographies of objects has been produced. This 'material turn' has also been directed at photography, most successfully by Elizabeth Edwards. See, for example, Elizabeth Edwards, *Raw Histories: Photographs, Anthropology and Museums* (London, 2001). Although I could not explore theoretical insights at any length here, my thinking about photographs as objects and in the construction of visual narratives has been informed by Edwards's work.

23 Elizabeth Edwards identifies two ways in which the term 'ethnographic' can be applied to photography. It can 'encompass both photographs made and circulated with ethnographic intention from the moment of inscription and those which, in the nineteenth century especially, became absorbed into anthropological spaces of consumption'. See 'Material Beings: Objecthood and Ethnographic Photographs', *Visual Studies*, XXVII/1 (2002). My usage in this chapter primarily refers to the former and the period of the 'fieldwork revolution' in the 1920s. Edwards's second definition undoubtedly applies to the material discussed in Chapter One.

24 For a history of the work of 'frontier cadres' see Alex McKay, *Tibet and the British Raj: The Frontier Cadre, 1904–1947* (London, 1997).

25 Charles Bell, *Portrait of a Dalai Lama* (London, 1946), p. 29.

26 Charles Bell, *Tibet: Past and Present* (London, 1924), p. 63.

27 Copies of Charles Bell's diaries and notebooks are held at the Liverpool Museum and the Pitt Rivers Museum, Oxford. Extracts from them are available on *The Tibet Album* website: http://tibet.prm.ox.ac.uk.

28 *The Tibet Album* reproduces the notes and lanternslides Bell used for this lecture. He also published an essay called 'A Year in Lhasa' in vol. LXIII of the *Geographical Journal* in 1924.

29 See Charles Bell's Lhasa diary, vol. X, p. 59, as reproduced on *The Tibet Album* website. The relationship between religion and Tibetan attitudes towards photography is considered more closely in Chapter Three.

30 On the identification of Rabden Lepcha as the creator of many photographs previously attributed to Bell, see *The Tibet Album*.

31 Hugh Richardson used the knowledge he had acquired during his long service in Tibet to write two major books, *Tibet and its History* (1962) and *A Cultural History of Tibet* (1968, with David Snellgrove), in which he endorsed the rights of Tibetans to claim a separate political identity from China.

32 See Hugh Richardson, *Ceremonies of the Lhasa Year* (London, 1994).

33 Lobsang Namgyal, the Ta Lama, became the head of Nechung Monastery and the state oracle of Tibet in 1934. Richardson visited him regularly at Nechung and 'in return he came frequently to Dekyi Lingka', the headquarters of the British Mission in Lhasa. See Richardson, *Ceremonies of the Lhasa Year*, pp. 49–50.

34 Tenzin Gyatso (14th Dalai Lama) quoted in John Clarke, *Tibet Caught in Time* (Reading, 1997), p. ix.

35 It would also encompass the area now defined as the Tibet Autonomous Region of the People's Republic, omitting the other Tibetan-speaking regions of China (Kham and Amdo) that are claimed by Tibetans in exile to be constituent parts of a larger, historic Tibetan nation.

36 Erik Mueggler's *The Paper Road: Archive and Experience in the Botanical Exploration of West China and Tibet* (Oakland, CA, 2011) includes a brilliant analysis of Rock's photography.

37 From 1904 onwards, the government of British India was generally disinclined to allow missionaries into Tibet. The few exceptions were the Moravians from Germany (based in the Western Himalayas) and a small mission station in Yatung that was run by a British woman, Annie Taylor, who was begrudgingly tolerated.

38 Shelton quoted in Douglas Wissing, *Pioneer in Tibet: The Life and Perils of Dr Albert Shelton* (New York, 2004), p. 122.

39 Shelton's biographer notes that 'ethnologic work' became his passion. See Wissing, *Pioneer in Tibet*, p. 153.

40 Albert Shelton, 'Life among the People of Eastern Tibet', *National Geographic*, XL (1921).

41 However, this is a paltry amount when compared to the $3,100 he received from the Newark Museum for his collection of Tibetan objects. See Wissing, *Pioneer in Tibet*, pp. 200–202.

42 Albert Shelton, *Pioneering in Tibet: A Personal Record of Life and Experience in the Mission Fields* (New York, 1921), pp. 148–9.

43 Ibid., p. 116.

44 The *New York Times* published eight illustrated essays by McGovern weekly, beginning on 9 September 1923. His book *To Lhasa in Disguise: An Account of a Secret Mission through Mysterious Tibet* appeared in 1924. McGovern later worked at Northwestern University in the U.S. Their online magazine of Spring 2010 states that 'few, if any, Westerners' had made the journey to Lhasa before him.

45 An English edition of Alexandra David-Néel's *Voyage d'une parisienne à Lhassa* was published as *My Journey to Lhasa* in London in 1986.

46 The most trenchant criticism appeared in 1972 in Jeanne Denys, *Alexandra David-Néel au Tibet (une supercherie dévoilée)* (Trickery Revealed). Denys had worked as David-Néel's assistant on her return to France from Tibet.

47 For further discussion of the creation of portraits of the 13th Dalai Lama in Darjeeling see Chapter Three.

48 Charles Suydam Cutting, *The Fire Ox and Other Years* (London 1947), p. 174.

49 The relevant chapter in *The Fire Ox and Other Years* is entitled 'Forbidden Cities of Tibet' (1947), pp. 173–246.

50 The Smithsonian in Washington, DC, curates Cutting's film from Tibet. Their database introduces him thus: 'Charles Suydam Cutting (1889–1972) was famous as the first Westerner to enter the Forbidden City in Lhasa, Tibet.'

51 See Chapter Five on 'Equivalent Images' in Poole, *Vision, Race and Modernity*.

52 Cutting, *The Fire Ox and Other Years*, p. 177.

53 Ibid., p. 206.

54 James Hilton, *Lost Horizon* (London, 1933).

55 The paradise of *shambhala* was originally described in an ancient Sanskrit text, the Kalachakra Tantra. For more on this see Donald Lopez, *Prisoners of Shangri-La: Tibetan Buddhism and the West* (Chicago, IL, 1998).

56 Theos Bernard, *Penthouse of the Gods: A Pilgrimage into the Heart of Tibet and the Sacred City of Lhasa* (New York, 1939).

57 Two biographies of Bernard have been published: Paul Hackett, *Theos Bernard, The White Lama: Tibet, Yoga and American Religious Life* (New York, 2012) and Douglas Veenhof, *White Lama: The Life of Tantric Yogi Theos Bernard, Tibet's Emissary to the New World* (New York, 2011).

58 Veenhof, *White Lama*, p. 214.

59 Ibid., p. 138.

60 Ibid., p. 251.

61 Quoted in Paul Hackett's doctoral thesis: 'Barbarian Lands: Theos Bernard, Tibet and the American Religious Life', Columbia University (New York, 2008), p. 216. Many thanks to Isrun Engelhardt for drawing my attention to this reference.

62 Gergan Tharchin is best-known among Tibetologists as the founder of the *Tibet Mirror*, a Tibetan language newspaper that he published from Kalimpong between 1925 and 1963.

63 Bernard, *Penthouse of the Gods*, p. 297.

64 For further discussion of Bernard's self-fashioning for magazines see Namiko Kunimoto, 'Traveller-as-Lama: Photography and the Fantasy of Transformation in Tibet', *Trans Asia Photography Review*, II/1 (2011).

65 Frederick Spencer Chapman, *Lhasa: The Holy City* (London, 1938).

66 Fosco Maraini, *Secret Tibet* (New York, 1953).

67 The only publication to give serious attention to photography during this mission is Isrun Engelhardt, ed., *Tibet in 1937–1938:*

Photographs from the Ernest Schäfer Expedition to Tibet (Chicago, IL, 2007). My essay in that volume tackles the 'ethnographic', 'diplomatic' and other modes of photography that were applied to Tibet in the 1920s and 1930s.

68 Rinchen Dolma Taring's *Daughter of Tibet* (London, 1970) provides further details of Tsarong's trading activities in British India within a rich account of her life in Lhasa and in exile in India.

69 Taring also tells us in *Daughter of Tibet* that her first husband, D. D. Tsarong, 'loved photography' (p. 79) and that her second husband, Jigme Taring, spent much of his spare time taking photographs in the company of Reting Rinpoche (p. 125).

70 In 1931 Mrs Leslie Weir gave an account of 'The Impressions of an Englishwoman in Lhasa' at the Royal Asiatic Society in London. The text was published in the Society's journal, vol. LXIV/1 (1932). Unfortunately her first name was not recorded and, since Leslie can be either a male or female name, there has been much confusion in the archives ever since. It has been claimed that Mrs Weir was the first Western woman in Tibet but in fact Alexandra David-Néel and Annie Taylor pre-date her.

71 'The Camera Pictorialists of Bombay' were founded in 1932 and by 1935 they had held their first exhibition in that city.

72 Li Gotami Govinda, *Tibet in Pictures: A Journey into the Past* (Berkeley, CA, 1979), p. xiv. The book claims that she was the first non-Tibetan woman permitted to live among celibate monks in a Geluk monastery.

73 Anagarika Govinda was a writer, painter, traveller and founder of the order of the Arya Maitreya Mandala, an organization that promotes Tibetan Buddhism in Europe.

74 Govinda, *Tibet in Pictures*, p. xiii.

75 Anagarika Govinda, cited in Govinda, *Tibet in Pictures*, p. xvi.

three Tibetan Encounters with the Camera

1 Archibald Steele reported from the Tibetan-speaking regions of China in 1939 and 1944. He re-published his articles *In the Kingdom of the Dalai Lama* (1993).

2 Heinrich Harrer published an account of the time he spent in Lhasa having escaped from an internment camp in British India in 1944 in *Seven Years in Tibet* (1953). He produced photographs and films while he was in Tibet. For his notes on the 14th Dalai Lama as cameraman see *Seven Years in Tibet*, pp. 250–51.

3 In September 2015 I had the honour of giving a presentation on some of the material described in this book for the 14th Dalai Lama. He generously answered my questions and corrected my errors.

4 On M. K. Gandhi's use of dress as a political tool see Emma Tarlo, *Clothing Matters: Dress and Identity in India* (Chicago, IL, 1996).

5 On 'Buddhist modernism' see Donald Lopez, *A Modern Buddhist Bible* (2002), and Georges Dreyfus, *The Sound of Two Hands Clapping: The Education of a Tibetan Buddhist Monk* (2003).

6 For a more detailed discussion of this topic see Clare Harris, 'The Politics and Personhood of Tibetan Buddhist Icons', in *Beyond Aesthetics: Art and the Technologies of Enchantment*, ed. C. Pinney and N. Thomas (London, 2001), pp. 181–99.

7 Jamyang Norbu's all-too-brief essay 'Photography and Tibet: A Historical Overview' is the only publication prior to this one to examine the development of photography among Tibetans. Jamyang's knowledge and writing has been hugely helpful to me and I hope he will soon publish more on the subject. In the meantime see http://philipmarshall.net/migyul/resources/culture/norbu_photography.htm, accessed 6 February 2016; and Jamyang Norbu, 'Tibet's First War Photographer', 22 November 2014, www.jamyangnorbu.com.

8 Roland Barthes, *Camera Lucida: Reflections on Photography*, trans. Richard Howard (New York, 1981), pp. 80–81.

9 Roland Barthes, *Camera Lucida: Reflections on Photography*, trans. Richard Howard (New York, 1981), p. 87.

10 For examples, see Kathryn Selig Brown, *Eternal Presence: Handprints and Footprints in Buddhist Art* (Katonah, NY, 2004).

11 Walter Benjamin, 'The Work of Art in the Age of Mechanical Reproduction', in *Illuminations*, ed. H. Arendt [1936] (New York, 1968), p. 221.

12 The concept of proxemics in photography is discussed at length by Christopher Pinney in *Photos of the Gods: The Printed Image and Political Struggle in India* (London, 2004).

13 Robert Linrothe, 'Travel Albums and Revisioning Narratives: A Case Study in the Getty's Fleury "Cachmire" Album of 1908', in *Photography's Orientalism: New Essays on Colonial Representation*, ed. A. Behad and L. Gartlan (Los Angeles, CA, 2013), p. 175.

14 I first published a discussion of this topic in 'The Photograph Reincarnate', in *Photographs Objects Histories: On the Materiality of Images*, ed. E. Edwards and J. Hart (London, 2004).

15 This information is derived from Sarat Chandra Das's 'Autobiography: Narratives of the Incidents of My Early Life', *Indian Studies: Past and Present*, X (1969). A lengthier analysis of Das's activities in Tibet, his relationship with the Sengchen Lama and his photography is contained in Clare Harris, *The Museum on the Roof of the World* (Chicago, IL, 2012), pp. 96–103.

16 A small collection of late nineteenth-century *cartes de visite* portraying senior Tibetan Buddhist monks and apparently printed in Russia appeared on eBay in 2015 for very high prices but with no information about exactly where they were made or by whom.

17 *The Graphic* was a weekly, illustrated newspaper that first appeared in London in 1869 and only ceased publication in 1932.

18 Charles Bell, *Portrait of a Dalai Lama: The Life and Times of the Great Thirteenth* (London, 1946), p. 114.

19 In 1999 I wrote that it was Charles Bell who created the first Tibetan Buddhist photo-icon when he took a portrait of the 13th Dalai

Lama in Darjeeling. See Clare Harris, *In the Image of Tibet: Tibetan Painting after 1959* (London, 1999), pp. 90–94. I have revised that presentation here in the light of new information acquired during my recent research on studio photography in the Himalayas.

20 An additional complication arises from the fact that prints and postcards of the 13th Dalai Lama were published both by Thomas Paar and John Burlington Smith. My research on photography in Darjeeling suggests that Paar's studio was taken over by Burlington Smith sometime after 1915 and that he continued to make copies from Paar's original glass plates.

21 It is likely that this photograph was taken in the shrine room at Bhutan House, the residence built for the 13th Dalai Lama in the nearby town of Kalimpong and occupied by him towards the end of his stay in India. This takes the date of the photograph to around 1912. I also think it is highly likely that Sonam Wangfel Laden La helped to arrange for this portrait to be taken since he had worked with Thomas Paar in a similar capacity in the past, was a senior member of the 13th Dalai Lama's entourage during his stay in India and was described by Charles Bell as his 'personal assistant' during that period.

22 My thanks to Bell's grandson, Jonathan Bracken, for sharing these pictures with me and passing on his astute observations about them. Jonathan also sent me a copy of the page in Bell's notebook where he recorded his donation of photographic equipment to the 13th Dalai Lama.

23 The 17th Karmapa, Ogyen Drodul Trinley Dorje, is the head of the Kagyu school of Tibetan Buddhism. He was born in Tibet and spent his teens at the historic seat of his predecessors at Tsurphu monastery, west of Lhasa, but in 1999 he left for India and is now based at Gyuto monastery near McLeod Ganj in Himachal Pradesh.

24 For examples of Tai Situpa's artwork and photography, see *Collection of the Creative Art Works of Xii Tai Situpa* (Taiwan, 2004).

25 Pierre Bourdieu, *Photography: A Middle-brow Art* (London, 1996).

26 Rinchen Dolma Taring, *Daughter of Tibet* (Delhi, 1970), p. 17.

27 Jamyang Norbu, 'Photography and Tibet'.

28 Photographs by Demo Rinpoche and some details of his life are recorded in Delphine Gao, 'The First Photographer of Tibet: Lopsang Jampal Loodjor Tenzin Gyasto Demo (1901–1973)', *Photographers International*, XXXIX (1998).

29 See Nicholas and Deki Rhodes, *A Man of the Frontier: S. W. Laden La (1877–1936), His Life and Times in Darjeeling and Tibet* (Kolkata, 2006).

30 By the end of his service Martin had stayed longer in Tibetan territory than any other European. His photographs were frequently reproduced in the publications of his superiors, including those of Charles Bell. For more information see Philip

Grover's entry on Martin in Clare Harris and Tsering Shakya, *Seeing Lhasa: British Depictions of the Tibetan Capital, 1936–1947* (Chicago, IL, 2003), pp. 156–7.

31 Eric Teichman, *Travels of a Consular Officer in Eastern Tibet* (London, 1922), p. 153.

32 Dundul Namgyal Tsarong is one of the few Tibetan photographers who published his own photographs (and some by his father) in a book. See D. N. Tsarong, *What Tibet Was* (Fontenay sous Bois, 1995).

33 Some information about Tseten Tashi and the history of his studio was published by Tenzing C. Tashi in 'In Fond Remembrance of our Yesteryears', *Sikkim Observer*, 25 August 2012.

34 Many prints by Tseten Tashi are now stored in the Newark Museum in the United States.

35 Further information about this tumultuous period in Tibet's history can be found in Tsering Shakya's *The Dragon in the Land of Snows: A History of Modern Tibet since 1947* (London, 2000), Melvyn C. Goldstein, *A History of Modern Tibet*, vol. II: *The Calm before the Storm, 1951–1955* (Oakland, CA, 2007) and his *A History of Modern Tibet*, vol. III: *The Storm Clouds Descend, 1955–1957* (2013).

36 Gao, 'The First Photographer of Tibet', p. 86.

37 For an example of an exhibition and publication featuring two Chinese photographers who worked in Tibet, see Huang Jianpeng, *Reviewing the Masterworks: A Selection of Ethnic Tibetan Related Photographic Artworks by Master Photographers Lan Zhigui and Zhuang Xueben* (Nanjing, 2010).

38 See, for example, Anna Louise Strong, *When Serfs Stood Up in Tibet* (1965). This book features text and photographs by a pro-Maoist American journalist who was in Lhasa when what she describes as the 'serf owner rebellion' of 1959 was put down.

39 Ackerly's photographs of the demonstrations in Lhasa in 1987 were published around the world at the time and then reproduced in *Tibet Since 1950: Silence, Prison and Exile* (New York, 2000). See also Steve Lehman, *The Tibetans: A Struggle to Survive* (New York, 1998).

40 Richard Gere published some of his Tibet photographs in *Pilgrim* (London, 1997).

41 On the Tibetan Contemporary Art movement see Chapter Seven and Chapter Eight in Harris, *The Museum on the Roof of the World*.

42 Tenzing Rigdol created 'Our Land, Our People' in 2011 to commemorate the death of his father in the United States. Having become a refugee in the 1960s, his father had never been able to return to his homeland. By bringing 20,000 kilograms of Tibetan soil out of Tibet and installing it in the 'capital in exile' in McLeod Ganj, Rigdol created an artwork with huge emotional force for all those who viewed it in India.

43 For further discussion of Tsewang Tashi's work see Chapter Seven in Harris, *The Museum on the Roof of the World*.

44 Chen Danqing's career in Tibet is described more fully in Harris, *In the Image of Tibet*, pp. 138–41.

45 For further discussion of this subject see Clare Harris, 'In and Out of Place: Tibetan Artists' Travels in the Contemporary Art World', *Visual Anthropology Review,* XXVIII/2 (2012).

46 When I met Tenzin Dakpa in 2013 we examined some of his work together. He has since moved to the U.S. but has continued to update me on the development of his practice.

47 In recent years, the poet and activist Tenzin Tsundue has become a heroic figure for other young Tibetans in India because he has organized a number of 'return' marches to Tibet. On each occasion the marchers were forced to turn back by the Indian police.

Epilogue

1 Quoted in Jiayang Fan, 'The Viral Wedding Photos that Conquered China', *New Yorker,* 29 April 2015, www.newyorker.com.

2 Gerong Phuntsok, cited in 'The Wedding Photos that Captivated China', www.bbc.co.uk/news, 18 April 2015.

Select Bibliography

Andreyev, Alexandre, ed., *Tibet in the Earliest Photographs by Russian Travelers, 1900–1901* (New Delhi and Berlin, 2013)

Barthes, Roland, *Camera Lucida: Reflections on Photography*, trans. Richard Howard (New York, 1981)

Behad, A., and L. Gartlan, eds, *Photography's Orientalism: New Essays on Colonial Representation* (Los Angeles, CA, 2013)

Bell, Charles, *Portrait of a Dalai Lama: The Life and Times of the Great Thirteenth* (London, 1946)

Benjamin, Walter, *Illuminations* [1936] (New York, 1968)

Bernard, Theos, *Penthouse of the Gods: A Pilgrimage into the Heart of Tibet and the Sacred City of Lhasa* (New York, 1939)

Bonvalot, Gabriel, and Henri d'Orléans, *De Paris au Tonkin à travers le Tibet inconnu* (Paris, 1892)

Bourne, Samuel, *Photographic Journeys in the Himalayas, 1863–1866* [1863–87] (Bath, 2009)

Candler, Edmund, *The Unveiling of Lhasa* (London, 1905)

Cutting, Charles Suydam, *The Fire Ox and Other Years* (London, 1947)

Das, Sarat Chandra, *A Journey to Lhasa and Central Tibet* (London, 1902)

Edwards, Elizabeth, 'Material Beings: Objecthood and Ethnographic Photographs', *Visual Studies*, XVII/1 (2002)

Egerton, Philip, *Journal of a Tour through Spiti to the Frontier of Chinese Thibet* [1864] (Bath, 2011)

Engelhardt, Isrun, ed., *Tibet in 1937–1938: Photographs from the Ernest Schäfer Expedition to Tibet* (Chicago, IL, 2007)

Falconer, John, 'Ethnographical Photography in India, 1850–1900', *Photographic Collector*, I (1984)

Govinda, Li Gotami, *Tibet in Pictures: A Journey into the Past* (Berkeley, CA, 1979)

Harris, Clare, *In the Image of Tibet: Tibetan Painting after 1959* (London, 1999)

—, *The Museum on the Roof of the World: Art, Politics and the Representation of Tibet* (Chicago, IL, 2012)

—, 'The Photograph Reincarnate', in *Photographs Objects Histories: On the Materiality of Images*, ed. E. Edwards and J. Hart (London, 2004)

—, 'The Politics and Personhood of Tibetan Buddhist Icons', in *Beyond Aesthetics: Art and the Technologies of Enchantment*, ed. C. Pinney and N. Thomas (London, 2001)

Lhalungpa, Lobsang, *Tibet the Sacred Realm: Photographs, 1880–1950* (New York, 1983)

McKay, Alex, *Tibet and the British Raj: The Frontier Cadre, 1904–1947* (London, 1997)

Pinney, Christopher, *Camera Indica: The Social Life of Indian Photographs* (Chicago, IL, 1998)

—, *The Coming of Photography in India* (London, 2008)

—, *Photos of the Gods: The Printed Image and Political Struggle in India* (London, 2004)

Poole, Deborah, *Vision, Race and Modernity: A Visual Economy of the Andean Image World* (Princeton, NJ, 1997)

Pratt, Mary Louise, *Imperial Eyes: Travel Writing and Transculturation* (London and New York, 1992)

Shelton, Albert, *Pioneering in Tibet: A Personal Record of Life and Experience in the Mission Fields* (New York and London, 1921)

Taring, Rinchen Dolma, *Daughter of Tibet* (Delhi, 1970)

Veenhof, Douglas, *White Lama: The Life of Tantric Yogi Theos Bernard, Tibet's Emissary to the New World* (New York, 2011)

Waddell, Laurence, *The Buddhism of Tibet or Lamaism: With its Mystic Cults, Symbolism and Mythology, and in its Relation to Indian Buddhism* (London, 1895)

—, *Lhasa and its Mysteries: With a Record of the Expedition of 1903–1904* (London, 1905)

Watson, J. F., and J. W. Kaye, eds, *The People of India: A Series of Photographic Illustrations, with Descriptive Letterpress, of the Races and Tribes of Hindustan*, 8 vols (London, 1868–75)

Wissing, Douglas, *Pioneer in Tibet: The Life and Perils of Dr Albert Shelton* (New York, 2004)

Acknowledgements

This book is a distillation of ideas and material that I have been working on for nearly two decades with help from a large number of people and institutions. I would like to begin by thanking Michael Leaman, who commissioned my first book *In the Image of Tibet* (1999) when I was still a doctoral student. It has been a pleasure to work with Michael and the staff of Reaktion Books once again.

My engagement with British collections of photographs from Tibet really began in earnest when I took up a post at the Pitt Rivers Museum in Oxford in 1998. 'Seeing Lhasa', an exhibition and book project (co-authored with Tsering Shakya in 2003), was designed to make Tibetan material in the collections of the Pitt Rivers more visible to the public. Working on *The Tibet Album* project with Elizabeth Edwards (then Curator of Photographs at the museum) and Richard Blurton (of the British Museum), and funding from the Arts and Humanities Research Council, enabled us to make 6,000 photographs of Tibet available to a global audience through *The Tibet Album* website that was launched by the 14th Dalai Lama in 2008. More recently, I have been able to enhance my knowledge of the history of photography in the Himalayas and Tibet thanks to a Research Fellowship from the Leverhulme Trust. I am also the grateful recipient of a Small Research Grant awarded by the British Academy. Their funding was essential since it covered travel to India and the substantial costs of the illustrations for this book. My research would not have been possible without help from members of Tibetan communities in India, the United States, the United Kingdom and the Tibet Autonomous Region of the People's Republic of China. Among them, I would particularly like to thank the artists, photographers, writers, Buddhist teachers and lay scholars who have been so generous in sharing their work with me over the years, and especially Tashi Tsering, of the Amnye Machen Institute in McLeod Ganj, whose erudition and enthusiasm for Tibet photography knows no bounds. Above all, there can be no greater honour than to have received the advice and support of the 14th Dalai Lama, as I did when I presented the outline of this book to him in Oxford in 2015.

Many other people have provided direct or indirect assistance for this book and the research that underpins it. I would like to thank my colleagues and students at the School of Anthropology and Museum Ethnography, and at Magdalen College, in the University of Oxford, for their intellectual input and patience during my absences on research trips. The same applies to the staff of the Pitt Rivers Museum and especially its former director, Michael O'Hanlon, who has been a constant source of wise words and inspiration. His recent retirement means that we feel a loss at the museum but we will continue the innovative work he promoted during his tenure. I also offer my gratitude to the following individuals: His Holiness the 17th Karmapa, Tai Situpa Rinpoche, Geshe Lhakdor, Isrun Engelhardt, Mauro Ribero, Fabio Rossi, Elizabeth Moir, Ann Slater, Donald Lopez, Christopher Pinney, Elizabeth Edwards, Tenzing Dakpa, Paljor Tsarong, Thupten Kelsang, Jonathan Bracken, Katie Paul, Andrea Ko, Jamie Owen, Jan Turner, Tony at Palpung, Jigme Namdol, Sonam Tsering, Rahaab Allana, Shilpi Goswami, Nyema Droma, Elizabeth Clarke, Tsewang Tashi, Anna Balicki-Denjongpa, Tenzing Rigdol, Hugh Rayner, David Churchill, Alastair Massey, Anna Smith, Henrietta Lidchi, Rosanna Blakeley, Patrick Sutherland, Monisha Ahmed, Bhutook, John Falconer, Malini Roy, John Ackerly, Tsering Shakya, Mandy Sadan, Durga Das, Jamyang Norbu, Kate Thaxton, Oscar Nalesini, Colin Harris, Deborah Klimburg-Salter, Jeannie and Philip Millward, Tsering Gonkatsang, Sedar Ball, Roger Croston, Victoria Connor, Liz Hallam, Dechen Pemba, Robert Beer, Håkan Wahlquist, Michael Black, Namiko Kunimoto, Sandra Matthews, Anna Luccarini, Mark Gunther, Gil Middleton, Vandana Prapana, David Clary, Kathy Clough, Philip Grover, Christopher Morton and the wonderful librarians, archivists and curators at the institutions listed in the Photo Acknowledgements.

The support of family and friends is crucial when the going gets tough, as it inevitably does on any book project, and I am extremely fortunate in this respect. My parents Reg and Beth Harris, my brother Graham (aka Reg) and members of the wider Harris-Gill family, plus a host of friends too numerous to list by name, have been cheering me on from the sidelines, but right in the thick of it on a daily basis have been my partner, Rupert Gill, and our son, Luke. Without their love, good humour and forbearance, I would achieve nothing.

Photography and Tibet is dedicated to Anthony Aris, who sadly passed away as I was completing it. He was a passionate supporter of all things Tibetan and had a particular enthusiasm for photography, having created many beautifully illustrated books at his publishing house, Serindia. He will be greatly missed.

Photo Acknowledgements

The author and publishers wish to express their thanks to the following
for illustrative material and/or permission to reproduce it.

John Ackerly: 101; Alinari Archives: 74; Alkazi Collection of Photography,
New Delhi: 19; courtesy the author: 20, 21, 22, 25, 29, 32, 64, 86, 88;
courtesy Bhutook, Dharamshala, India: 87; Bodleian Library, University
of Oxford: 6, 7; courtesy Jonathan Bracken and the family of Charles Bell:
54, 89, 91; courtesy the British Library, London: 36 (photo 430/53[2]), 37
(photo 430/53[3]), 90 (photo 1083/17); Bundesarchiv Koblenz, Germany:
75 (135 KB-15-083 photo Ernst Schäfer), 76 (135 S-13-07-45 photo Bruno
Beger); © Centre Culturel Maison Alexandra David-Néel, Digne-les-
Bains, France: 63; Trustees of the Chhatrapati Shivaji Maharaj Vastu
Sangrahalaya, Mumbai: 79, 80, 81, 82; David Churchill: 26; Tenzing
Dakpa: 106, 107; Nyema Droma: frontispiece, 108, 109; *Family Circle*
magazine and the Meredith Corporation: 72; Getty Images: 85; Getty/
Phil Borges: 103; Hugh A. Rayner Photograph Collection: 3, 4, 5, 8, 9, 10,
11, 12, 13, 14, 15, 16; Library of Tibetan Works and Archives, Dharamshala,
India: 84, 97; Magnum/Steve McCurry: 102; Elizabeth Moir and the
family of Sonam Wangfel Laden La: 93; Jigme Namdol: 110; courtesy
the Council of the National Army Museum, London: 43, 44, 45; Newark
Museum, New Jersey: 59 (20.140 I), 60 (20.1392), 61 (49.1070), 62
(20.1486), 65 (50.2570), 66 (50.2600), 67 (73.1136), 95 (2000.36.3.64),
96 (2000.36.3.9); The Palpung Organisation and Tai Situpa Rinpoche,
Northern India: 92; PARS International/*Time* magazine: 83; © Phoebe
A. Hearst Museum of Anthropology, University of California, Berkeley:
69, 70, 71; Pitt Rivers Museum, University of Oxford: 46 (1998.131.305.1),
47 (1998.285.162), 48 (1998.285.215), 49 (1998.285.214.1), 50 (1998.285.54.1),
51 (1998.285.224), 52 (1998.285.223.1), 53 (1998.285.312.1), 55 (2001.59.2.1),
56 (2001.59.9.38.1), 57 (2001.59.9.47.1), 58 (1998.157.87), 73 (1998.157.76),
77 (1998.131.522), 78 (1998.157.95); Tenzing Rigdol/Rossi and Rossi: 104;
Royal Anthropological Institute, London: 23 (RAI 199 Lhamo, © RAI),
24 (RAI 198 © RAI); Royal Geographical Society, London (with IBG):
1, 18, 35, 40, 42; Royal Norfolk Regimental Museum, Norwich: 41; Sven
Hedin Foundation/Stockholm Museum of Ethnography, Sweden:
39 (1025.0232); Tsewang Tashi/Rossi and Rossi: 105; courtesy Paljor
Tsarong: 94; University of Cambridge Library: 17; and courtesy the
University of Pennsylvania Museum of Archaeology and Anthropology,
Philadelphia: 27 (151008), 28 (151016B), 30 (243660), 31 (243665).

Index